Margaret Wharton

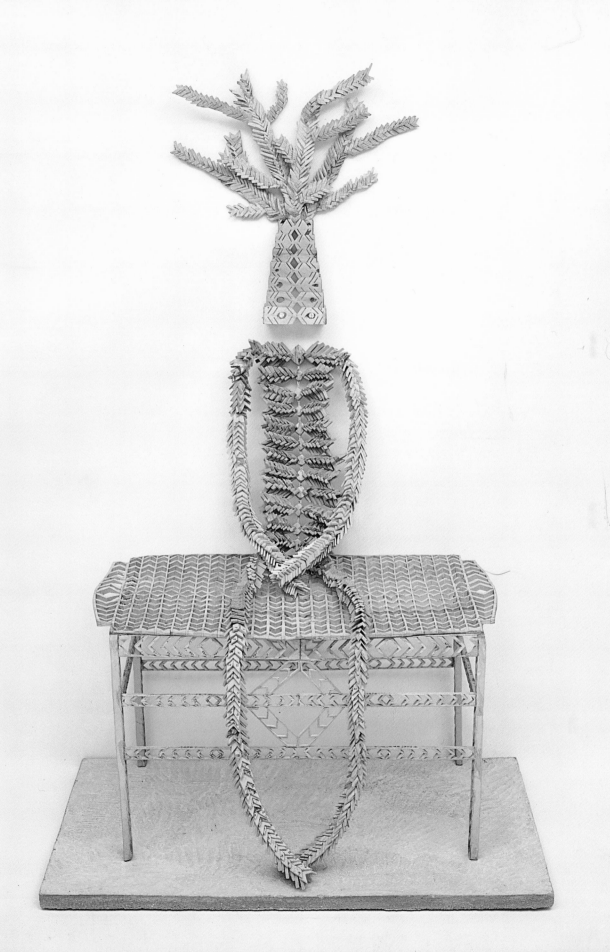

Margaret Wharton

Museum of Contemporary Art, Chicago

September 12—November 1, 1981

Tour

Museum of Contemporary Art, Chicago
September 12-November 1, 1981

Laguna Gloria Art Museum, Austin, Texas
January 15-February 28, 1982

University of South Florida Art Galleries; Tampa
April 2-May 8, 1982

Designed by Michael Glass Design, Chicago, Illinois

Typeset in Sabon by Dumar Typesetting, Inc.,
Dayton, Ohio

2,000 copies were printed on Warren Lustro Offset
Enamel by Eastern Press, New Haven, Connecticut

Cover: *Wallflower* (cat. no. 38)

Photo Credits
Unless indicated below, all photographs repro-
duced in this catalogue are by William H.
Bengtson, who furnished as well the cover
illustration and color plates.

Art Institute of Chicago, fig. 1.
Detroit Institute of Arts, fig. 5.
Jonas Dovydenas, cat. nos. 2, 5.
Carole Harmel, fig. 2.
Pace Gallery, New York, fig. 3.
Carol Turchan, fig 7.
Walker Art Center, Minneapolis, Eric Suther-
land, fig. 4.
Margaret Wharton, figs. 9-11.

This exhibition and catalogue are made possible
with grants from the National Endowment for
the Arts, a federal agency; the Illinois Arts
Council, a state agency; and Borg-Warner
Foundation, Inc., Chicago.

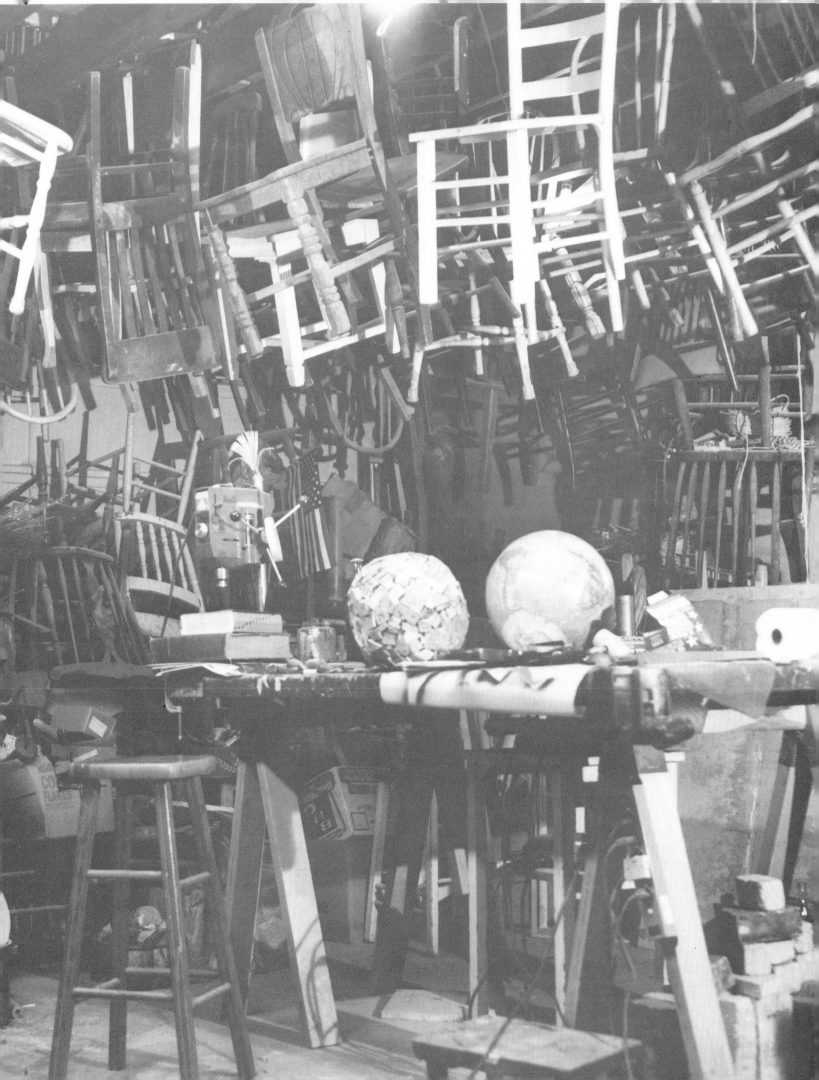

Preface

The Museum of Contemporary Art is very pleased to be able to present this first museum exhibition devoted to the work of Margaret Wharton. The 80 works from 1975-81 assembled here permit us the opportunity to see again favorites that have long since entered private collections or left Chicago; a number of works shown only in New York are new even to Wharton's admirers here. That this exhibition is traveling to other museums around the country suggests that the artist's intensely personal vision has attained a certain level of enriched, shared communication which is in the sculpture itself, independent of her presence: this is one way of saying that this is art in the best sense of the term, art that is not limited to one time or place.

To Margaret Wharton, who has assisted in every aspect of the exhibition preparations, including a special installation for the MCA's Bergman Gallery, and to Mary Jane Jacob, Museum Curator, who organized the exhibition and wrote the catalogue, we are all most grateful. Their collaboration has produced a publication which serves both as a useful guide to the works themselves and as a basis for subsequent research.

On behalf of the artist, curator, and the Museum, I would like to acknowledge and thank the following for their specific contributions:

The lenders to the exhibition for sharing the objects of their enthusiasm with all of us.

Jerry Silberman, Chairman of the Exhibition Committee, Helyn D. Goldenberg, Museum President of the Board of Trustees, and especially Joseph R. Shapiro for their encouragement and support.

Members of the Museum staff: Lynne Warren, Curatorial Assistant and Mary Ahrendt, Curatorial Secretary; Linda Glass and Mark Pierce, Museum Interns; Mary Braun, Registrar; Ted Stanuga, Chief Preparator; Naomi Vine, Director of Education; and Dennis O'Shea, Museum Technician.

Phyllis Kind, Karen Leininger, and Carol Celentano of the Phyllis Kind Gallery, Chicago and New York.

Terry Ann R. Neff, Catalogue Editor; Michael Glass, Designer of this publication; and especially William H. Bengtson who contributed the major part of the photographs and who generously assisted with various aspects of organizing the exhibition.

Participating institutions whose interest has helped to ensure the fulfillment of the exhibition in its intended scope: Laurence Miller, Director, and Annette Carlozzi, Curator, Laguna Gloria Art Museum, Austin; and Margaret A. Miller, Director, University of South Florida Art Galleries, Tampa.

In conclusion, a very sincere thank you to those institutions and individuals whose financial support has enabled the MCA to pursue the challenge and responsibility of this exhibition and publication: the Museum Program of the National Endowment for the Arts, a federal agency; Borg-Warner Foundation, Inc., and to William M. DuVall, President, for ongoing support of MCA exhibitions of artists working in Chicago; the Illinois Arts Council, a state agency; and special funds from the Phyllis Kind Gallery, Sherry and Alan Koppel, and William H. Plummer.

John Hallmark Neff
Director

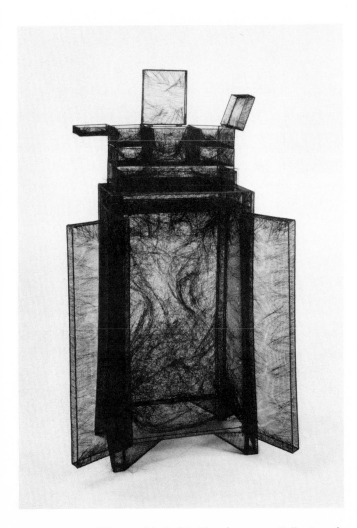

Fig. 1. Margaret Wharton, *My Lady's Chambers,* 1974. Collection of the artist.

The work of Margaret Wharton featured in this exhibition dates from 1975, a seemingly short time, yet for Wharton a most important and fruitful period of significant achievement. Arriving during these years at a medium and method all her own, she has been able to create a variety of forms and images in art. In all her sculptures, most of which are derived from the form of a chair, a strikingly human quality predominates. This aspect, which comes in part from the artist's personal interpretation and our associations with each piece, gives to Wharton's work the power that we sense as we confront the objects that populate her world.

Wharton was born in Portsmouth, Virginia in 1945. She studied advertising at the University of Maryland and after graduation in 1965, Wharton, by then married, turned to raising a family in Bethlehem, Pennsylvania. She was able to pursue her art only part-time, and during this period made jewelry and small, welded metal sculptures of simple, linear elements that she exhibited and sold at local art shows. After moving in 1968 to the suburbs of Chicago, where she still resides with her two children, a dramatic change occurred in Wharton's personal and artistic life.

The late 1960s and early 1970s was an era of social upheaval on many levels in the United States, particularly with regard to the status of women. Altering their personal family relationships in order to take on new roles, many women redirected their lives to allow for more personal growth. Margaret Wharton's life was profoundly affected by the women's movement at that time. In 1971 she separated from her husband and, seeking a constructive and interesting outlet for her energies, returned to school. She soon devoted herself entirely to this program of study, receiving her Master of Fine Arts degree from the School of the Art Institute of Chicago in 1975, the same year she finalized her divorce. The exposure to not only a broad spectrum of methods and concepts, but also to working professional artists, was influential on Wharton during her years at the school. The experience was also positive in redirecting her activities for the future, thanks to the encouragement of teachers who supported her early efforts. Artists Richard Keene, Ray Yoshida, and Jim Zanzi, and art historian/theoretician Jack Burnham played important roles in this regard. Also significant were artists such as Jenny Snider and Ree Morton,[1] whom Wharton came to know through the artist-in-residency program initiated and developed by Richard Loving. During this student period the support of other women in Chicago who shared their interests and struggles was also profoundly important to Wharton. In 1973 she helped found Artemisia, Chicago's first women's cooperative gallery.[2] It was in these years that Wharton achieved personal independence as well as artistic maturity.

While a graduate student in sculpture, Wharton had continued to pursue her interests, experimenting with various materials to create recognizable, everyday items. These works were informed by Claes Oldenburg's reinvented objects, whose properties challenge our normal expectations. Applying the technique of welding that she had mastered, she made pieces such as a heavy metal vest with fabriclike texture on one side and actual cloth on the back, and an eight-foot dress welded out of steel window screening. *My Lady's Chambers* (fig. 1), which in 1974 won a prize in the Art Institute's "Seventy-fifth Exhibition by Artists of Chicago and Vicinity," is a more surreal work. The protruding, hairlike, tangled black wires that fill the various compartments of this

welded wire chest give it a strange, threatening quality. Also at this time Wharton made a series of small, mysterious seaweed boxes, at once sensual and repulsive. In her simultaneous exploration of interior and exterior aspects, use of boxlike enclosures, varied textures, and mood, pieces such as *My Lady's Chambers* and *Phaeophyta II* (fig. 2), one of her series of boxes, are directly linked to the work of Lucas Samaras, which had first impressed Wharton in the mid-1960s when she saw a magazine reproduction of one of his pin-encrusted boxes (see fig. 3). Through such artists as Samaras and Oldenburg, Wharton shares a peculiarly 20th-century interest in common objects as the potential form and content of art, notably with Dada beginning in the teens and 1920s, Surrealism, and increasingly with the emergence of Pop Art in the 1960s.

In this context there are numerous precedents for the use of chairs: from Marcel Duchamp's *Bicycle Wheel* upside down on a stool to eccentric versions of real chairs by Oldenburg; nonfunctional furniture sculptures by Barbara Zucker, Joel Shapiro, and Richard Artschwager, for which the chair is the formal source; or works that incorporate actual chairs, such as Edward Kienholz's environments, Robert Rauschenberg's combines, or Joseph Kosuth's reading rooms. From 1964 to 1970 Lucas Samaras—again an important reference for Wharton—created his well-known chair transformations, a series of decorative variations in chair-like form (see fig. 4). Most notable during the last decade are Scott Burton's sculptures; they look and function as furniture, draw upon the history of decorative arts, and often parody past styles and tastes (see fig. 5). For Burton, his chairs are an extension of his earlier work in performance art. Creating tableaux of his furniture, these objects take the place of and function as the characters in a play in which the sets say everything. As opposed to Burton's furniture which replaces people, Wharton transforms her chairs into people with a believable spirit of their own.

Both Samaras and Burton seek to make sculptures that are recognizable as and refer to being chairs; whether designed and fabricated out of new or found materials, they have not had a previous existence as chairs. With Wharton the emphasis is on the chair as medium, as object rather than subject. She does not focus on chairs themselves, their stylistic history, or even the function of sitting. In the other examples mentioned above, the pieces, functional and nonfunctional, retain their "chairness" in look, purpose, or both. These artists create chairs; Wharton creates sculptures from chairs, finding in them images and ideas.

Because of its form and associations, the chair is a rich source of information—abstract structure, figurative references, and symbolic connotations. First of all, chairs have a clarity of form in their use of vertical, horizontal, and sometimes curved lines. Secondly, chairs are anthropomorphic in character, being bilaterally symmetrical and having legs, arms, a back, and a seat. Moreover, the symbolism of the chair is varied. Intimately associated throughout history with human activities and rituals, they stand as symbols of civilization, having literally and metaphorically both elevated and separated human beings from the earth. The range of associations with chairs is as various as the sources and styles of the object itself: a seat of authority and power, a sign of profession or status, or an artifact of a particular time or culture. The chairs that Wharton selects—common wood ones mostly of the kitchen

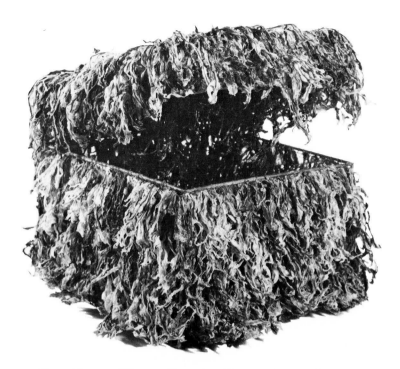

Fig. 2. Margaret Wharton, *Phaeophyta II*, 1974. Private Collection, Chicago.

Fig. 3. Lucas Samaras, *Untitled Box #3*, 1963. Collection of the Whitney Museum of American Art, New York.

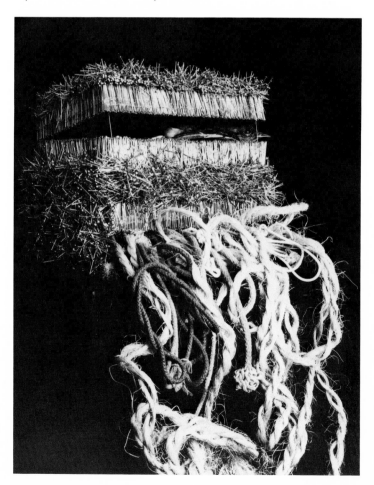

Fig. 4. Lucas Samaras, *Untitled*, 1965. Collection of the Walker Art Center, Minneapolis.

Fig. 5. Scott Burton, *Chair, Bronze Replica Series,* 1975. Collection of the artist, courtesy of Max Protetch Gallery, New York.

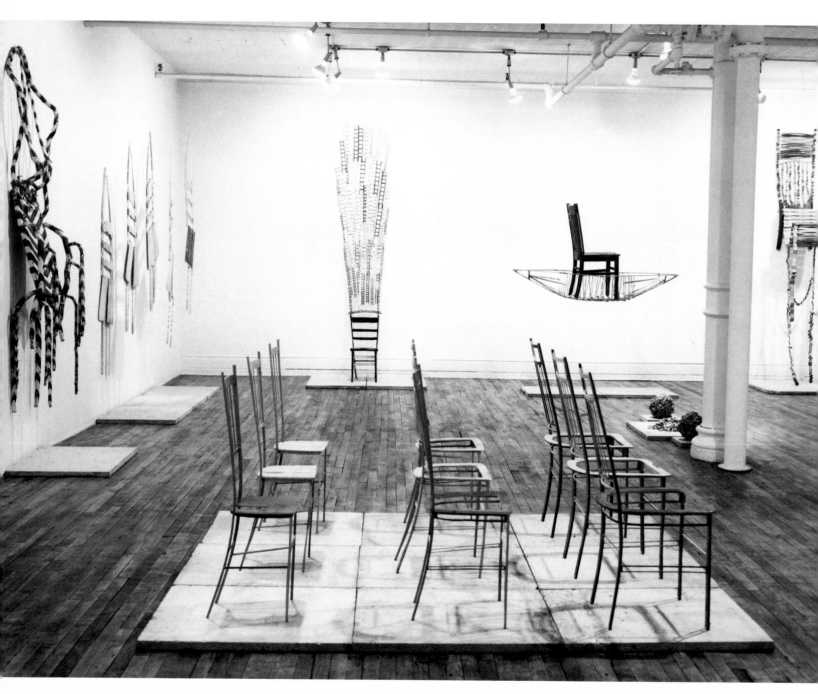

Fig. 6. Margaret Wharton, installation at Phyllis Kind Gallery, New York, 1976. From left to right: *Scorpion* (cat. no. 14), *Parade from Art-park* (cat. no. 19), *1³* (not in exh.; Collection of the Whitney Museum of American Art, New York), *Zed* (cat. no. 17), *Difficult Crossing* (cat. no. 18), *mass* (cat. no. 4), and *Accordion Chair* (not in exh.; Collection of the Madison Art Center, Wisconsin).

variety—are at once almost styleless in their simplicity and linked to feelings of comfort and home. Wharton also consistently makes use of old, worn examples, a fact that remains evident even in their transformed state. In her process of disassembly and reconstruction, as in an assemblage technique, Wharton alters a found object with a previous life and brings it into an art context. But unlike most assemblage constructions, Wharton's art is not the joining together of disparate elements, but the restructuring of parts from a single source, usually a single chair. There is an economy of means in Wharton's drawing from within a plain and unpretentious object a new reality; it is not an additive or subtractive process, but rather a re-creation of what exists. This limitation makes the resulting sculpture all the more remarkable.[3]

Setting a specific boundary at the outset—to work with common, used wood chairs—Wharton proceeds in an intuitive manner of investigation, while also employing a logical process. At the same time she takes clues from forms emerging along the way as the piece is cut and put back together, the rational aspect of her art is apparent in her careful cutting of the chair, numbering or otherwise identifying of the parts, and systematic recording. The greatest influence on her method of working was her father, a research zoologist and teacher. Wharton visited her father's laboratory and observed his experiments. This early exposure is seen in Wharton's process of dissection and reassembly; she considers her art to be her research; making each piece is like solving a new problem or writing a paper on a different topic.

Not surprisingly, the early pieces are the most directly analytical. In *mass* (cat. no. 4), one of her first experiments, Wharton completely cut up a chair and rolled it into a ball form. For another, *Cache* (cat. no. 1), the pieces of a chair were numbered and placed inside a suitcase, creating an ironical traveling chair; a level was supplied to aid in its reconstruction. These pieces were followed by a 20-foot-long series made from 40 chairs in which Wharton investigated the physical decomposition of a chair from a standing object to a pile of sawdust (fig. 7), and a study in the classification of the structure of a 20-foot slab of concrete broken up and numbered. In *Veneer Specimen No. 1* and *No. 2* (cat. nos. 6, 7), her first works having an actual chairlike form, she affixed the parts of a chair to glass to create the impression of a specimen on a microscope slide. Similarly, in her works at Artpark in 1976, she disassembled two copies of *Webster's Dictionary*, gluing them to plastic to create a single sheet (cat. no. 55), then manipulating it to form sequentially a striped painting, a side of a house, a tent, a figure, and finally a sheet folded back inside the cover (cat. no. 56). In 1^3 (see figs. 6, 8) Wharton set herself the task of separating as many chairs as possible out of a single chair; the resulting chairs were of relatively equal size. Although other pieces may not reveal Wharton's process of investigation so clearly, she has applied her analytical method to all her works, other items of furniture (a desk, cat. no. 30; and stool, cat. no. 47), and common objects (baseball bats, cat. nos. 39-42; books; yardsticks; golf clubs; and so on).

In addition to the analytic, more systematic side of Wharton's work, there is a strong mystical element, and it is this quality that gives her art its special power and life. Even though the original shape of the chair is nearly obliterated in Wharton's restructuring

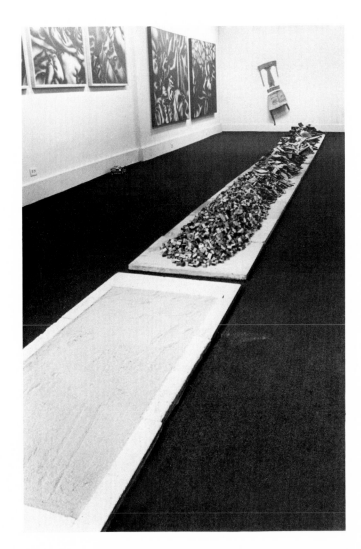

Fig. 7. Margaret Wharton, installation at Artemisia Gallery, Chicago, 1975.

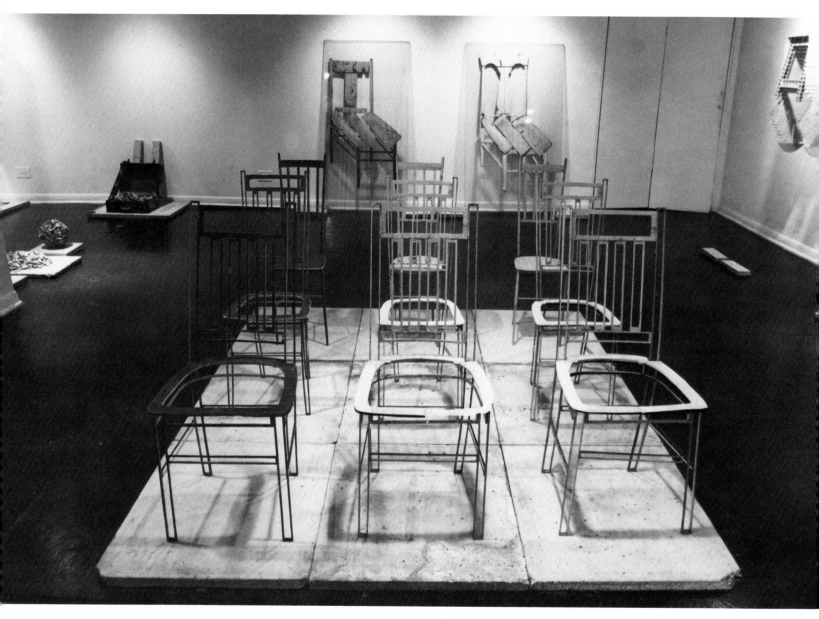

Fig. 8. Margaret Wharton, installation at Phyllis Kind Gallery, New York, 1976. From left to right: *mass* (cat. no. 4), *Cache* (cat. no. 1), *1³* (not in exh.; Collection of the Whitney Museum of American Art, New York), *Veneer Specimen No 1* and *No. 2* (cat. nos. 6, 7), and *Winged Altar* (cat. on 16).

Fig. 9. Margaret Wharton, *Anthesis* (cat. no. 61), detail.

process, the fact that the piece was originally a chair is essential to the conception of the work. Wharton's sculptures carry within them the history of their past life; not only is the final form reminiscent of a chair, but the worn surfaces are rich with associations of past experiences. Wharton retains not only the memory of the previous specific existence, but also infuses a sense of past reaching beyond the life of the particular object. She believes that women seem to have ready access to a genetic memory that goes far beyond their own biological years; her objects are imbued with this cumulative sense of time. A mystical quality also arises from Wharton's use of materials. Because she restricts herself for the most part to the object, drawing from the chair itself new forms and meanings, her sculptures seem to be the product not only of a process of analysis, but also of mystical or spiritual rebirth. Wharton's destruction of the chair's form and erasing of its function is a necessary death that serves as a prelude to a reincarnation of the material through restructuring it into a new and different manifestation. This is especially clear in a piece such as *Epigenesis* (cat. no. 9), with its name telling of the process of metamorphosis that all Wharton's work undergoes. It is an early and key example for understanding the fundamental basis of the artist's work.

Sometimes Wharton explores an entire continuum of transformations before arriving at a final solution for a piece, documenting in sculptural forms and photoseries a range of possible resolutions. For instance, she photographed *Wallflower* (cat. no. 38) at various stages in different outdoor settings, each taking on a distinct character (cat. nos. 65-70). The sculpture *Garden Chair* (cat. no. 26) was preceded by a photoseries titled *Anthesis* (cat. no. 61). Initially to enhance the worn surface quality of an old green chair, the artist buried it in her yard for one year. This did little to change the chair, but it did serve as the inspiration for a ritual recording of the exhumation. In a sequence of seven photographs, Wharton tells of the simultaneous birth and rebirth of the object, or if read in reverse, its death. Placing a white sheet around the pit in which the chair had been buried and wrapping another sheet around the chair, she created a scene that looks at once like both a fetus in the womb or a newborn in swaddling clothes, and a shrouded corpse in a grave. The unwrapping became a metaphor for the birth of a new life and/or the rebirth of a former one; in reverse, the wrapping was the putting to rest of the deceased. The photoseries is bracketed by views of the empty pit stamped with the impression of the chair—a haunting reminder of its former state. In one version of this piece Wharton made a circular band from a strip of small contact prints. This emphasized yet another interpretation of this series as illustrating the cyclical nature of life that has its turning point at the anthesis, or full flowering: once one has reached a point of maturity and level of knowledge, it is time to begin the descent and die; then the cycle is renewed.

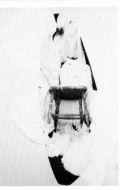

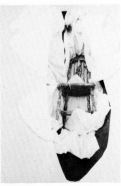

All of Wharton's art is highly evocative of ideas beyond that of "chair." It is the richness and variety of these references that continue to make her work vital. Several trends can be observed as one examines chronologically the forms Wharton has explored. In addition to the analyses of structure already discussed, Wharton's earlier work is generally more somber in tone and formally linked more often to the chair shape; since 1978 she has increasingly pushed the source object to its physical and conceptual extremes. The result is a myriad of exuberant and fanciful forms that rarely reveal their former state.

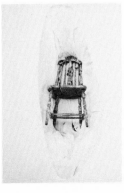

In many of her chair pieces from 1975-76, Wharton made specific religious references which are for the most part associated with Christianity. Perhaps her Lutheran minister grandfather was a particularly powerful early influence; today Wharton's interest continues to be fostered by her collecting of souvenir artifacts and symbolic, mystical objects. Most of her religiously-oriented sculptures make use of the anthropomorphic features of the chair, using a chairlike form to imitate the human figure. Outstanding among these works is *Trinity* (cat. no. 5), which was exhibited in Wharton's Art Institute graduate fellowship show and subsequently in the traveling "Improbable Furniture" exhibition. *Trinity* consists of three similar and equal forms derived from one substance; as such it is not merely a simple formal problem, but also elucidates a basic tenet of the Roman Catholic religion. Like God the Father, Christ the Son, and the Holy Spirit, these three chairs are one in essence. They hang magically transfixed in mid-air, not bounded by the earth. *Martyr* (cat. no. 3), its name evoking those individuals who have sacrificed themselves for their religion, hangs limp and dead, its body sagging after being subjected to a careful process in which it was cut into many parts, numbered, and then wired back together into a ghostly impression of its original form. *Eliyahu* (cat. no. 2) seems to have the presence of a body lying in state, or of a tomb effigy. *Epigenesis* is the story of the Resurrection: from its decaying shell it re-emerges renewed. *Zed* (cat. no. 17), although not having a specific reference, takes on the quality of an ascending spirit.

The bond between the clergy (as God's representatives) or God Himself and man, the believer, is the theme of *Communion* (cat. no. 23). In the closeness of the two figures and air of confidentiality, this piece also seems to refer to the confessional. The larger figure may even allude specifically to the Pope: a papal cap crowns the top of the vertical brace. The smaller figure carries a Bible, and both bear the sign of the cross, a symbol of faith, in the formation of their back braces. Both figures are also made from the same chair originally, the smaller being fashioned from inside the larger, reminding us that man is made in God's image. This piece is also about meditation or spiritual communication with oneself. Both chair forms are in fact only one in essence; here the body and soul or conscious and unconscious minds of a single individual have split. In the modern world it is perhaps in turning to oneself rather than to a god that one comes to terms with existence. *Difficult Crossing* (cat. no. 18)[4] alludes to our passing from this world to the next. Wharton draws upon the boat as an ancient symbol of transport to the next world. In Greek mythology, for example, the boatman Charon ferries souls of the dead across the River Styx to Hades. Yet as in the final judgment one has only oneself to rely upon, so too in this suspended voyage to the next world, it is a solitary spirit that moves on: both boat and rider are made of the same chair.

A devotional idea also finds expression in shrine works such as *Winged Altar* (cat. no. 16) and *Indian Wish* (cat. no. 11). Also related is *Idol Chair* (cat. no. 10), which is a totemic image of a

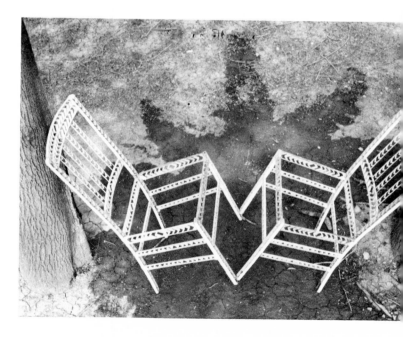

Fig. 10. Margaret Wharton, *Drawbridge* (cat. no. 67).

central figure adorned by fan-shaped offerings. A few works such as *Cardinal Order* (cat. no. 8) or *High Chair Around a Pole* (an earlier and no longer existing version of *Eiffel Tower*, cat. no. 34) allude to a throne or prestigious seat for a spiritual leader, in the latter case specifically the Polish Pope John Paul II. *Rain Cloud* (cat. no. 30) seems to extend the devotional theme to a primitive culture. In addition to depicting a figure on a bench under a cloudburst, it also suggests a king or priest seated on a throne, communicating with the forces around him. One of four miniature photochairs, each made by wrapping a photograph of an actual chair around a newly fabricated chairlike armature, *Sacred Bull* (cat. no. 48) is one of the most effective throne pieces and is powerfully moving despite its small scale. The horns projecting from each side at the top make it appear like the seat for a high priest of an unknown cult, while the title alludes to the sacred animals of India. These aspects are combined with the image of crucifixes, Christianity's most important symbol, ironically establishing a link with Western religion.

The works which follows this first group of sculptures, in a lighter, more playful vein, continue to draw upon the chair form's potential to express human qualities and traits. One of the first and simplest of these works is *Parade from Artpark* (cat. no. 19), made from a single character in *Maids-in-Waiting*, a long series of chairs atop a hill, each wearing a long white veil. This romantic scene created at Artpark was recorded by Wharton in a photograph (cat. no. 57). Later one chair from this group was sliced into

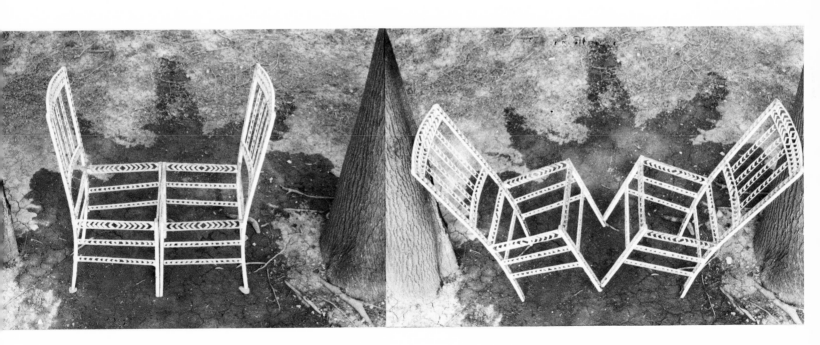

an arrangement of five animated and lively figures who dance in different positions along the wall. In addition to *Parade,* several other works refer to people while retaining their chairlike look. *Friends* (cat. no. 25; also see cat. no. 62) is an exercise in how to make two totally complementary parts; if the figure were to take a seat, he would become one with his chair. In *Tall Story* (cat. no. 37) and *Family* (cat. no. 50), Wharton pulled out smaller chairs from a larger one; in the former the parent chair, or authoritarian figure, towers over two smaller, obedient characters in a gesture of instruction or command; in the latter the traditional husband dominates over the wife, child, and dog—all of whom are physically and imagistically derived from the father. In this way *Family* deals with the idea of nesting, both of the family as a protective nest, and as a unit that can be nested or fit back inside each other. To create *Consommé* (cat. no. 24), two chairs were cut from the same half-chair; the other half was used to make the table, bowls, and picture. This creation of an entire scene is unusual in Wharton's oeuvre; the two chair figures function as both seats and sitters, facing each other as if conversing within a room. Two particularly poignant works are the portraits of Georgia O'Keeffe and Frida Kahlo. *Morning Bed* (cat. no. 28), a totem to O'Keeffe, includes one of this artist's frequent subjects, a cow's skull and horns.[5] The colors (tan, blue, and white) all reflect O'Keeffe's own subtle palette, and the worn surface of the piece creates an impression not unlike the bleached and weathered look of O'Keeffe's New Mexican landscapes. *Portrait for Frida Kahlo* (cat. no. 29), a

moving tribute to the beautiful Mexican painter, was directly inspired by Wharton's visit to the 1978 retrospective exhibition of Kahlo's work at the Museum of Contemporary Art in Chicago. It also draws upon childhood memories of Mexico where Wharton lived at a young age for about a year while her father was doing research there. Forbidding and austere, like Kahlo's own formidable countenance it is composed of many pointed and prickly segments. The sculpture is open in the center, displaying its weakened core, as a reminder of Kahlo's injured spine and pelvis that tortured her all her life, prevented her from successfully having children, and finally led to her early death at the age of 44. The words "White Hell" that appear on the seat stress the pain this woman endured through life, and conjure up images of both a freezing, icy-white hell or fiercely burning white-hot embers. The color also, in combination with the detailed, cathedrallike shape, makes this a monument to Kahlo's ultimate transcendence from this world.

Other single-figure works take on the guise of a personality type: *Archetype for the Professor* (cat. no. 22) is cut into squares held together by seam binding and is fringed with black tassels made of the same material, recalling an academic costume; *Figurine* (cat. no. 35), a poised ballerina, and *General Nonsense* (cat. no. 44), a spirited and comical officer, are both created through flattened, decorative arrangements of the chair parts. Despite the references to a chair (back braces, skirt-seat, legs, and rungs) in *Odalisque* (cat. no. 45), the greatly exaggerated scale, shiny, glistening fragments of paint, and seductive, reclining pose all speak

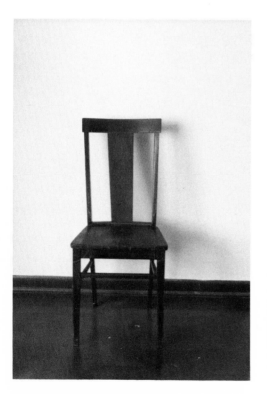 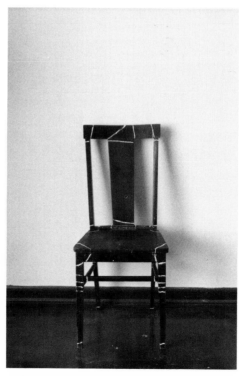 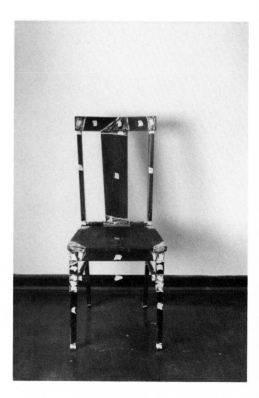

Fig. 11. Margaret Wharton, *Making Friends* (cat. no. 62).

convincingly of the reality of the figure. One of Wharton's most elaborate works, *Wallflower* (cat. no. 38) is an example of Wharton's use of double meanings. This shy, lonely figure seated against the wall—the wallflower kept in the sidelines of social activity—sits demurely, legs and arms crossed; her tearful rhinestone eyes tell of her rejection or perhaps reflect an inner awareness of what it means to be alone. At the same time this figure is a tree or plant form—a botanical wallflower—with roots, trunk, and branches, crowned with a burst of foliage and placed upon a lattice or trellislike bench.[6] The earlier photographic studies of this work in progress (cat. nos. 65-70), shot against flowers and trees, hint at the final image, although, as in all her work, Wharton did not have a preconceived subject in mind.

Human forms are also the subject of two of Wharton's recent series of photochairs. *Diamond Lill* (cat. no. 43) is an homage to the famous actress Mae West (whose death coincidentally occurred as Wharton was completing the piece).[7] The surface is a photograph of the original chair wrapped in clear plastic—a sensual, revealing material that takes on the quality of a fancy satin garment; this is studded with rhinestones and crowned with white feathers. *Jestress* (cat. no. 51) has a similar form and headdress, but the type of decoration (glass balls and bells), brightly colored patches, and expandable, acrobatic legs give it the gaiety and humor of an entertaining clown.

In addition to human figures, Wharton's transformations have extended to the animal world. *Scorpion* (cat. no. 14) and *Garden Chair* (cat. no. 26) make reference to insects. Slicing chairs in multiple layers to expand their dimensions, Wharton shaped the wingspread of *Dove* (1980; Collection of James Mayor, London); and *Mockingbird* (cat. no. 52). Each bird retains its chairlike form: *Dove* whose breast has a flattened double chair outline, and *Mockingbird* in which, after furnishing the wings, a miniature chair remains to form the body, its feet carved into claws, its head and breast painted with gold stripes. *Bantam Chair* (cat. no. 33) is a four-legged creature with a narrow body and neck, topped by a flurry of plumage; its striping, head feathers, and title make it an odd juxtaposition of zebra and roosterlike qualities. *Reversible Pegasus for Joseph Campbell* (cat. no. 32), based on the mythological flying horse, is one of Wharton's simplest, most direct forms; here the focus is on the elements inserted in the chair rather than the nature of the transformed chair. On one side is an issue of *Natural History* superimposed with a crucifix; on the reverse is an issue of *Scientific American* on which is placed a photograph of a child in a papoose. *Pegasus* presents Wharton's view of how throughout time man has created myths to explain the world; as Pegasus was a myth, so too are religion and science. Doctrines, both religious (signified by the cross) and scientific *(Scientific American)* are continually imposed on nature and people, bringing about an ongoing series of changes that end for all time the natural state of things. In its title Wharton dedicates this piece to Joseph Campbell, author of books on world mythology.

Although for the most part, Wharton's work has made ref-

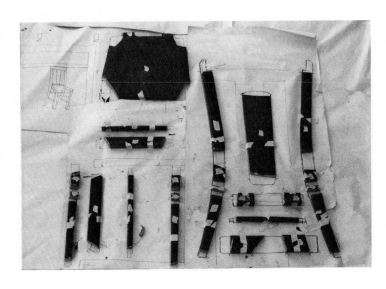

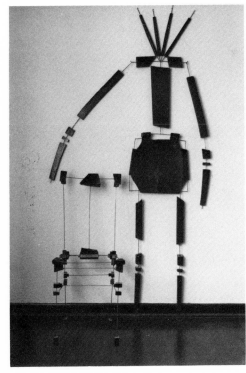

erence to human archetypes and personalities, she has periodically created pieces that also touch upon other themes, such as architecture. *Eiffel Tower* (cat. no. 34), for instance, is a child's highchair extended by drawing from within, progressively smaller chairs that are then piled up on each other. Here Wharton compares the structure of this turn-of-the-century Parisian technological wonder to that of the highchair from which her version is constructed. She also juxtaposes the idea of a chair used for feeding a child to the Eiffel Tower's symbolically nourishing man's urge to build higher and higher, making monuments to his own achievements, no matter how impractical. *Parsee's Hat* (cat. no. 47), the title recalling the Parsee in Rudyard Kipling's story "How the Rhinoceros Got His Skin," is also a tower structure and, like the *Eiffel Tower*, is created through the same process of expansion, but here it is topped off with an animated, whimsical cap similar to those worn by members of this Indian sect. *Tall Story* (cat. no. 37), in its height and title, refers to skyscrapers; a window in the central structure reflects the smaller buildings on each side. *Valley Bridge* (cat. no. 15), like many of Wharton's works, has an ironical twist in name and form. The seats of two chairs were sliced to form a continuous structure between these otherwise unaltered objects. But instead of rising above ground level to join the two parts, Wharton's bridge takes on the V-shaped configuration of a valley. (A similar sculpture was created in 1973 by Robert Rauschenberg. In this piece from his Venetian series, he used two chairs with a sheet draped between them to create the illusion of architecture, the church of Sant'Agnese.) Wharton has also made alterations to chairs in order to give the impression of a piano, as in *Middle C* (cat. no. 12) and *Recital* (cat. no. 53). A more elaborate work totally removed from its original chair form is *Sung Dynasty* (cat. no. 21), in which Wharton made a birdcage with an Oriental flavor. Also among the objects that Wharton has created from chairs are chairs themselves. In *Paperweight* (cat. no. 36) she took a part of an actual three-dimensional chair (the other half was used for *Figurine*), flattened it out, cut the parts into paper-thin sections, and, as earlier in *Veneer Specimen No. 1* and *No. 2*, reassembled it into a two-dimensional version of a chair, but this time as if drawn in perspective on a piece of paper.

Wharton's alteration of chairs is a process of humanization. The hidden potential of the object is revealed through a series of investigations over time prior to the making of the piece. Sometimes Wharton creates scenarios with them, decorates the surfaces, or manipulates them in other ways—either before taking the chair apart or during the construction process. If not actually transforming the inanimate object with which she begins into a personnage, still she endows the new form with human traits or a lifelike vitality. Her wit and her desire to transmit an enlivened spirit to her art can be seen not only in the forms she creates, but in her titles, which are an important factor in her art and give clues to some of her associations.

Once the restructuring is complete, the new object stands linked, yet distinct from its past as a chair and from the artist who made it. Magically, it takes on a new identity and meaning. Wharton's technique, unique and so perfectly skillful, reinforces the illusion; often one cannot easily imagine how the form came from such a simple and ordinary-looking chair. It is the human quality of her work and its visual and narrative strength that engage us and bring our world and Wharton's together.

Mary Jane Jacob
Curator

Footnotes

1
Most noteworthy among artists who have undertaken a similar change of personal life was Ree Morton. After separating from her husband, she went on to produce work of emotional expression and freedom, rapidly building a successful art career, tragically curtailed by her death in an automobile accident in Chicago in 1977. Wharton was familiar with Morton's work, having been a student at the School of the Art Institute of Chicago when Morton was visiting artist in 1974; Wharton also saw her Chicago show that year. Morton and Wharton met again when both were at Artpark the summer of 1976.

2
The following women, along with Wharton, were the original organizers of Artemisia: Phyllis Bramson, Shirley Federow, Sandra Gierke, Barbara Grad, Carole Harmel, Vera Klement, Linda Kramer, Phyllis MacDonald, Susan Michod, Sandra Perlow, Lee Pinkowski, Joy Poe, Claire Prussian, Nancy Redmond, Christine Rojek, Heidi Seidelhuber, Alice Shaddle, Mary Stoppert, and Carol Turchan.

3
This same sense of economy characterizes the constructivist sculptures of Polish artist Katarzyna Kobro (1899-1951) in which she cut and folded rectangles of metal to create geometric, abstract architectural works.

4
Wharton derived this title from a painting by René Magritte, *La Traversée Difficile,* 1926, Private Collection.

5
This same device was used to create two related works, *Longhorn* (cat. no. 27) and *Rainbow Skull* (cat. no. 31).

6
For a complete and insightful analysis of this piece, see Joanna Frueh, "Chair Persons: Margaret Wharton," *The Reader,* Chicago, January 11, 1980.

7
Mae West was also captured in furniture form on two occasions by Salvador Dali: in a 1934 gouache (Collection of the Art Institute of Chicago) in which her face became a room, her hair the draperies pulled back, eyes the framed landscape paintings, nose a fireplace, and lips a couch—an idea developed two years later into an actual pink satin sofa entitled *Mae West's Lips*.

(Height precedes width precedes depth. All
dimensions are for sculpture without bases,
except nos. 29, 32-37, 43, 46-48, 50, 51, 53, and
54.) An asterisk is used to indicate works shown
in Chicago only.

Sculpture

* 1. *Cache* 1975
 Painted wood chair, level, and suitcase on
 concrete base
 Box: 38.1 x 29.2 x 29.2 cm (15 x 11½ x 11½ in.)
 Collection of William Copley, New York

2. *Eliyahu* 1975
 Partial stained wood chair and wire on concrete
 base
 5.1 x 116.8 x 156.2 cm (2 x 46 x 61½ in.)
 Collection of Roger Brown, Chicago

3. *Martyr* 1975
 Painted wood chair, epoxy glue, felt tip marker,
 and wire
 127 x 40.6 x 38.1 cm (50 x 16 x 15 in.)
 Collection of Mr. and Mrs. E. A. Bergman,
 Chicago

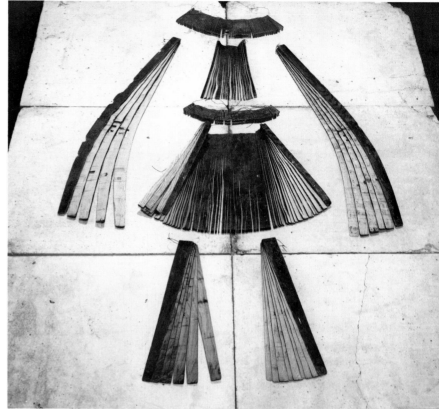

2

1

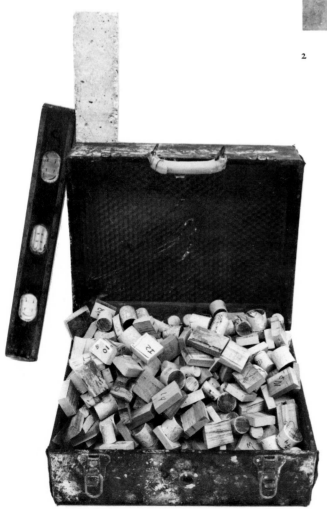

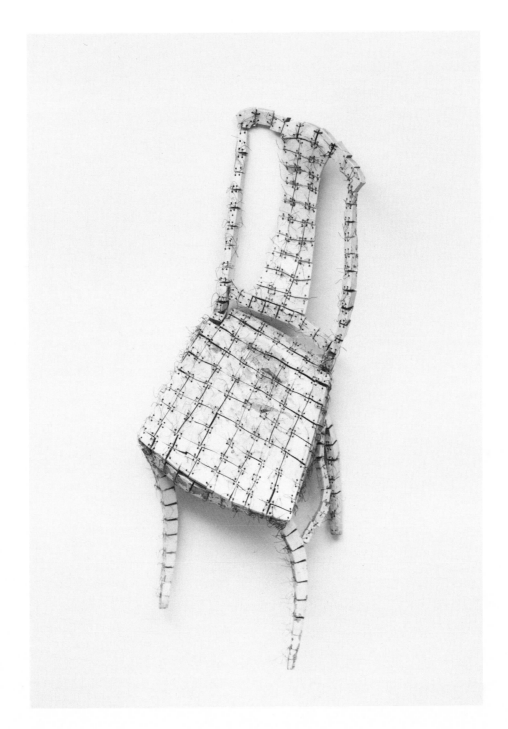

3

* 4. *mass* 1975 (reworked 1981)
 Painted wood chair and epoxy glue with metal
 globe stand
 40.6 x 35.6 x 26.9 cm (16 x 14 x 11 in.)
 Lent by the artist, courtesy of Phyllis Kind
 Gallery, Chicago and New York
 See fig. 6

 5. *Trinity* 1975
 Painted wood chair, epoxy glue, and nylon
 monofilament
 106.7 x 152.4 x 30.5 cm (42 x 60 x 12 in.)
 (dimensions variable)
 Collection of Joan and Michael W. Zavis,
 Highland Park, Illinois

* 6. *Veneer Specimen No. 1* 1975
 Partial painted wood chair, epoxy glue, and glass
 152.4 x 80 x 10.2 cm (60 x 31½ x 4 in.)
 Collection of Mr. and Mrs. Roger W. Barrett,
 Winnetka, Illinois
 See fig. 8

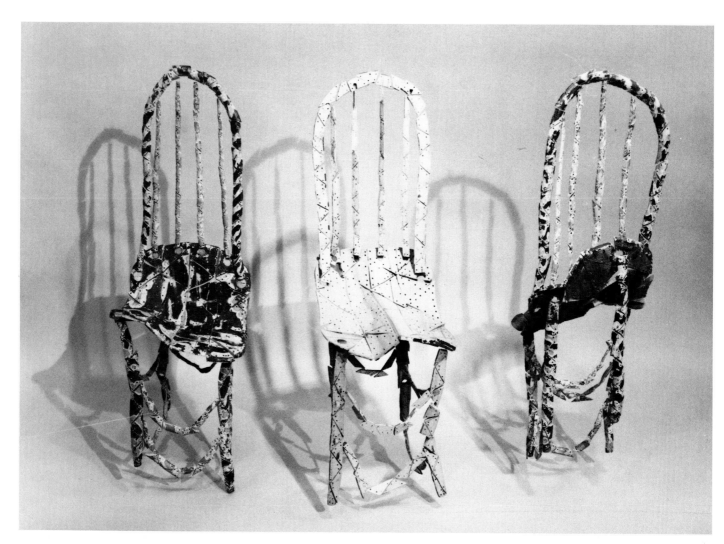

5

*7. *Veneer Specimen No. 2* 1975
Partial painted wood chair, epoxy glue, and glass
152.4 x 80 x 10.2 cm (60 x 31½ x 4 in.)
Collection of William Copley, New York
See fig. 8

8. *Cardinal Order* 1976
Stained wood chair, epoxy glue, glass, and wood
dowels on concrete base
124.5 x 44.5 x 53.3 cm (49 x 17½ x 21 in.)
Collection of Karen Leininger, Chicago

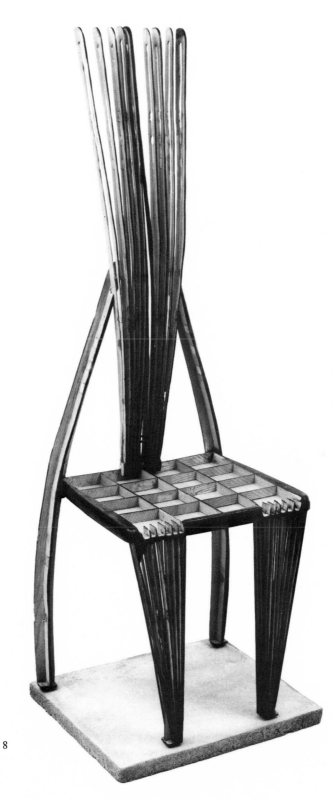

8

9. *Epigenesis* 1976
Painted wood chair, epoxy glue, and wood
dowels on concrete base
89 x 81.3 x 38.1 cm (35 x 32 x 15 in.)
Private Collection, New York

10. *Idol Chair* 1976
Painted wood chair, epoxy glue, and wood
dowels on concrete base
223.5 x 91.4 x 86.4 cm (88 x 36 x 34 in.)
(dimensions variable)
Collection of Jerrold Basofin, Chicago

* 11. *Indian Wish* 1976
Partial stained wood chair, epoxy glue, and wood
dowels with concrete base
160 x 71.1 x 38.1 cm (63 x 28 x 15 in.)
(dimensions variable)
Collection of William H. Plummer, Chicago

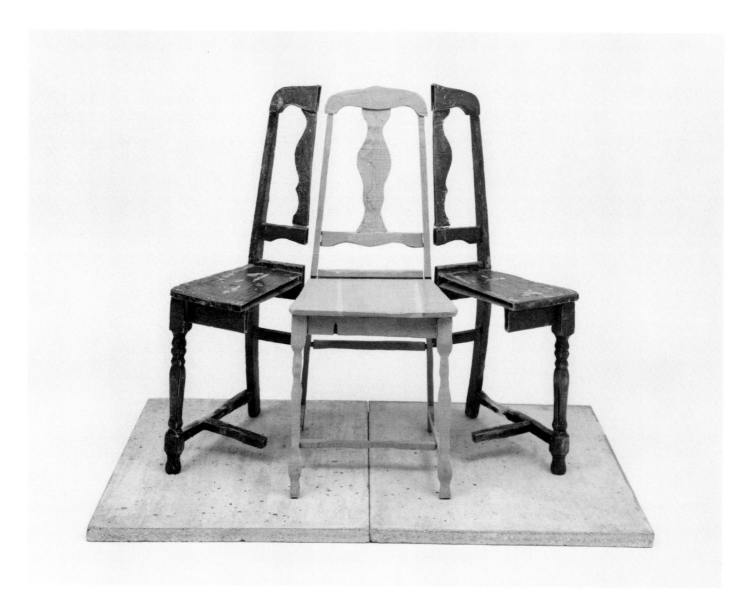

9

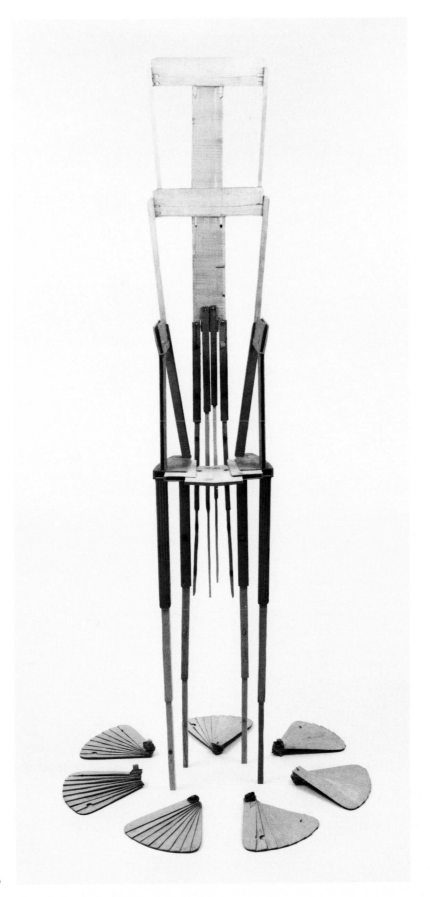

10

12. *Middle C* 1976
 Stained wood chair, epoxy glue, and steel rods
 on concrete base
 76.2 x 40.6 x 40.6 cm (30 x 16 x 16 in.)
 Collection of William H. Plummer, Chicago

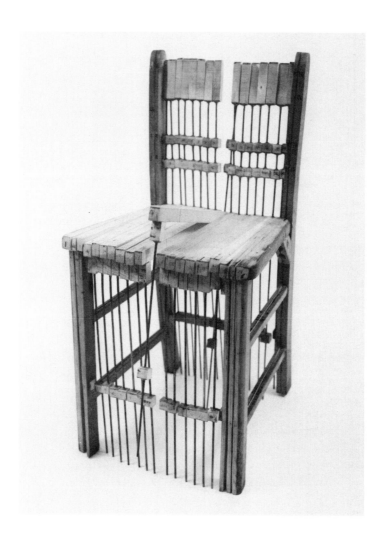

13. *Scribe* 1976
Painted wood chair, epoxy glue, and wood
dowels on concrete base
104.1 x 62.2 x 41.3 cm (41 x 24½ x 16¼ in.)
(dimensions variable)
Private Collection, Chicago

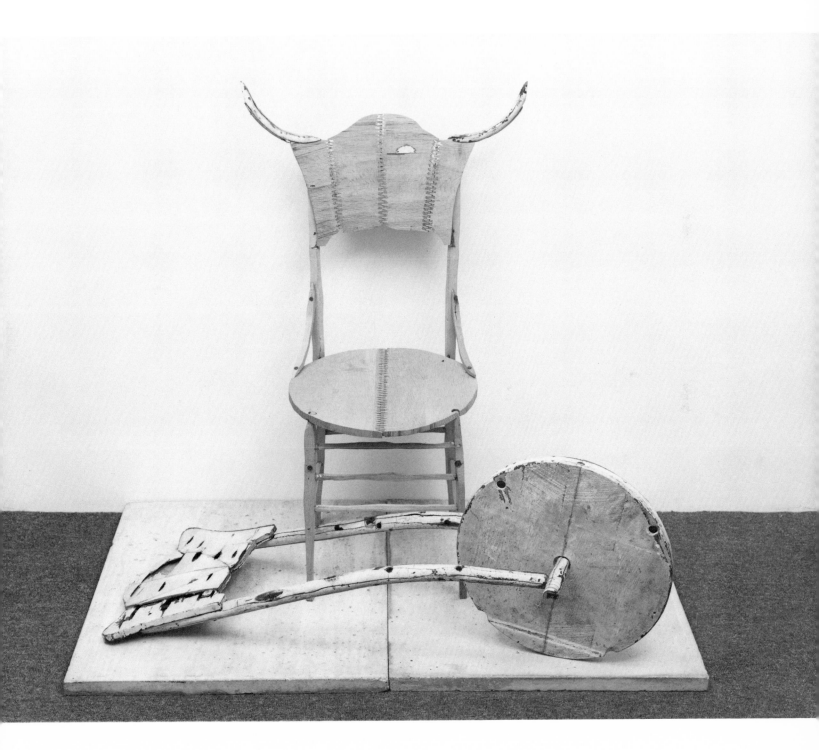

14. *Scorpion* 1976
 Two painted wood chairs, epoxy glue, and steel rods
 203.2 x 81.3 x 25.4 cm (80 x 32 x 10 in.)
 Collection of Joan and Michael W. Zavis, Highland Park, Illinois

15. *Valley Bridge* 1976
 Two painted wood chairs, epoxy glue, and wood dowels
 72.4 x 266.7 x 36.8 cm (28½ x 105 x 14½ in.)
 Courtesy of Phyllis Kind Gallery, Chicago

* 16. *Winged Altar* 1976
 Painted wood chair, epoxy glue, thread, and wood dowels
 134.6 x 35.6 x 33 cm (53 x 14 x 13 in.)
 (dimensions variable)
 Collection of Susan and Chuck Michod, Chicago
 See fig. 8

17. *Zed* 1976
 Painted wood chair, epoxy glue, and wood dowels on concrete base
 254 x 83.8 x 27.9 cm (100 x 33 x 11 in.)
 (dimensions variable)
 Collection of Milly and Arnold Glimcher, New York
 See fig. 6

* 18. *Difficult Crossing* 1977
 Stained wood chair, epoxy glue, steel rods, wire, and wood dowels
 101.6 x 172.7 x 66 cm (40 x 68 x 26 in.)
 Collection of Linda and Harry Macklowe, New York

14

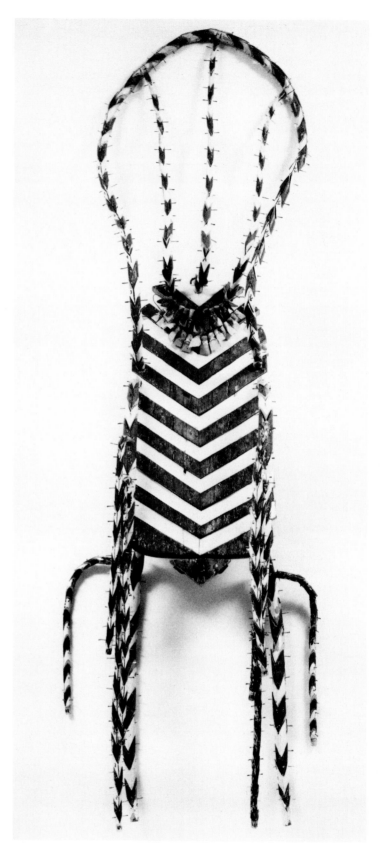

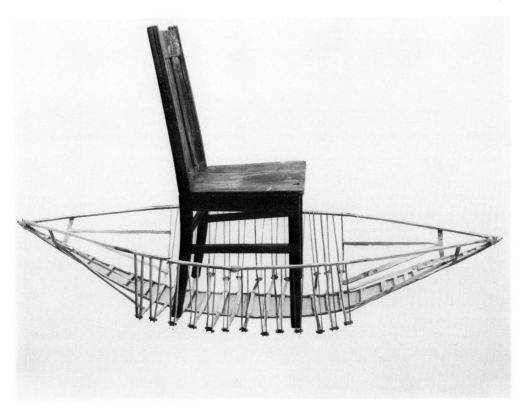

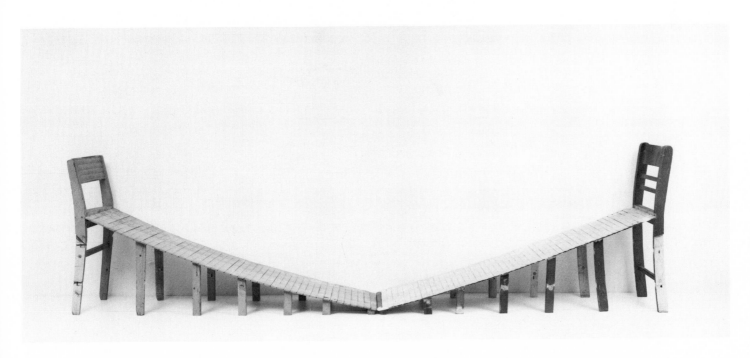

* 19. *Parade from Artpark* 1977
 Painted wood chair, epoxy glue, luminous paint,
 and wood dowels
 137.2 x 279.4 x 30.5 cm (54 x 110 x 12 in.)
 (dimensions variable)
 Collection of Gerald A. Gitles, Chicago
 See fig. 6

20. *Relic* 1977
 Stained wood chair, epoxy glue, hinges, and steel
 rods on concrete base
 110.5 x 36.8 x 15.2 cm (43½ x 14½ x 6 in.)
 (dimensions variable)
 Private Collection, New York

* 21. *Sung Dynasty* 1977
 Child's painted wood chair, epoxy glue, wire,
 and wood dowels
 139.7 x 55.9 x 55.9 cm (55 x 22 x 22 in.)
 Collection of Mr. and Mrs. E. A. Bergman,
 Chicago

22. *Archetype for the Professor* 1978
 Partial wood chair, epoxy glue, seam binding,
 and wood dowels on concrete base
 101.6 x 40.6 x 43.2 cm (40 x 16 x 17 in.)
 Private Collection, New York

23. *Communion* 1978
 Partial painted wood chair, Bible, epoxy glue,
 and wood dowels
 119.4 x 45.7 x 45.7 cm (47 x 18 x 18 in.)
 Collection of Mr. and Mrs. John B. Pittman,
 St. Charles, Illinois

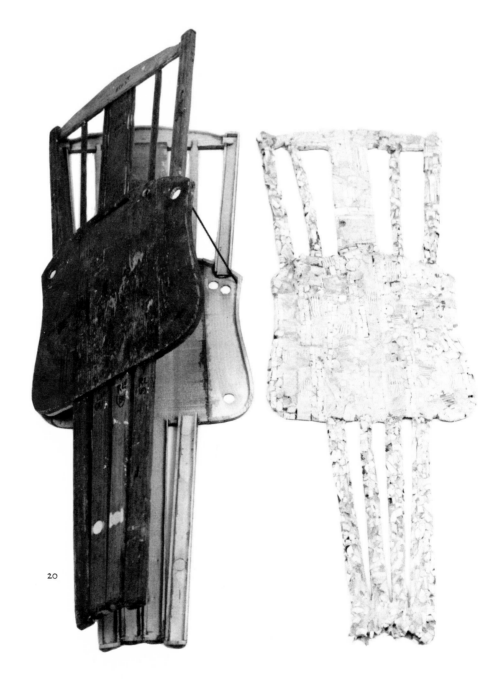

20

28

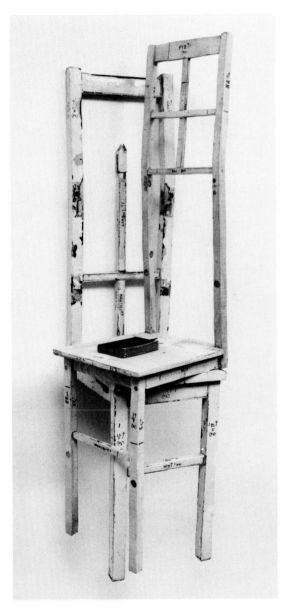

23

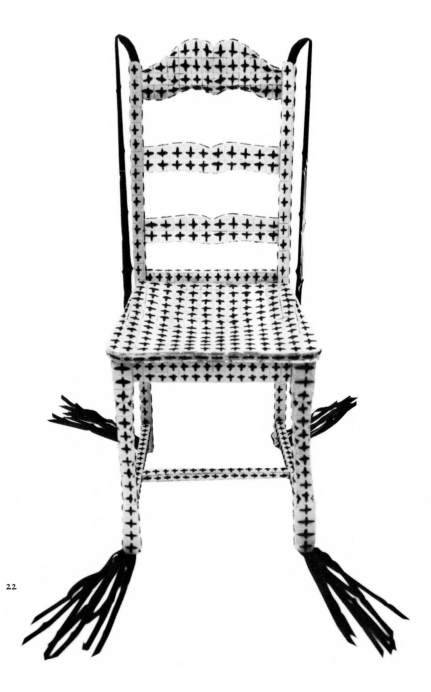

22

29

24. *Consommé* 1978
Partial stained wood chair, epoxy glue, glass,
reeds, string, wire, and wood dowels on concrete
base
124.5 x 142.2 x 39.4 cm (49 x 56 x 15½ in.)
Collection of Dr. and Mrs. Robert H. Kirschner,
Chicago

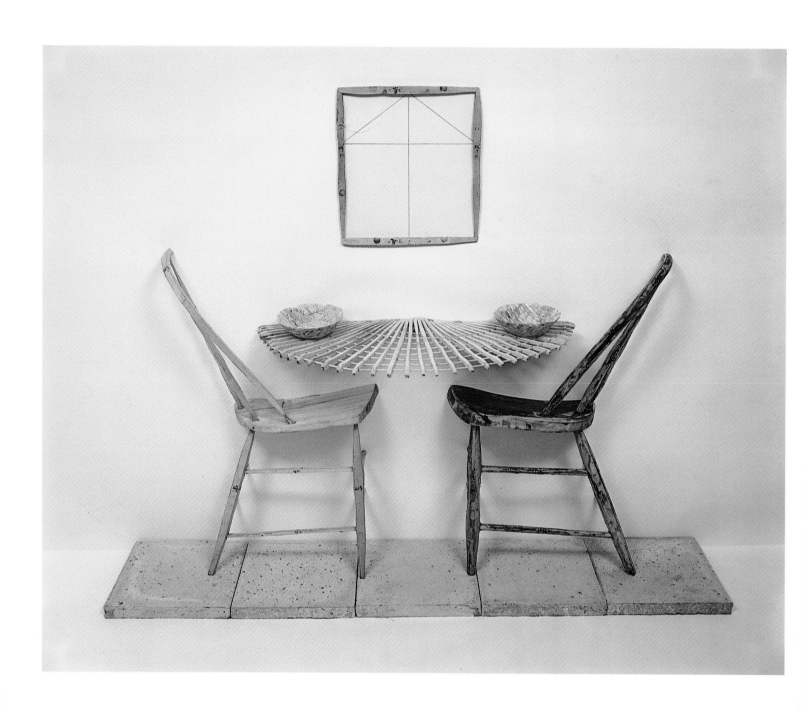

25. *Friends* 1978
Stained wood chair, epoxy glue, and steel rods on
concrete base
193 x 114.3 x 40.6 cm (76 x 45 x 16 in.)
Collection of Maxine and Jerry Silberman,
Glencoe, Illinois

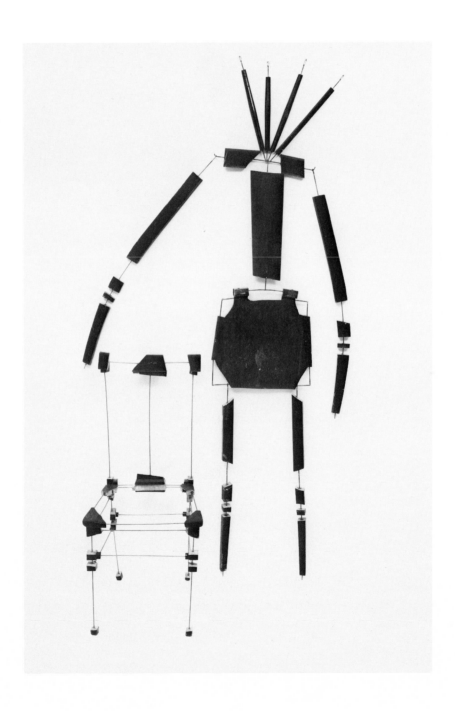

26. *Garden Chair* 1978
Painted wood chair, epoxy glue, reeds, staples,
and wood dowels
243.8 x 109.2 x 5.1 cm (96 x 43 x 2 in.)
Collection of Susan and Lewis Manilow, Chicago

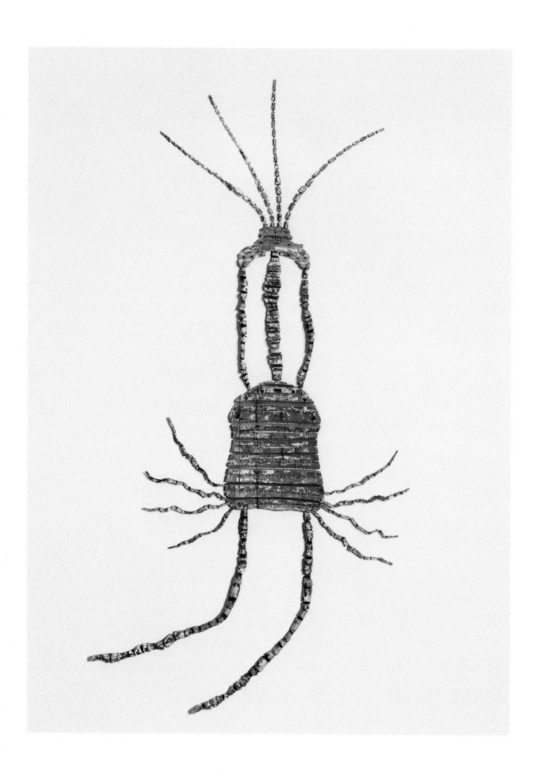

* 27. *Longhorn* 1978
Partial painted wood chair and epoxy glue
172.7 x 198.1 x 30.5 cm (68 x 78 x 12 in.)
Collection of Evelyn and Lawrence Aronson,
Glencoe, Ilinois

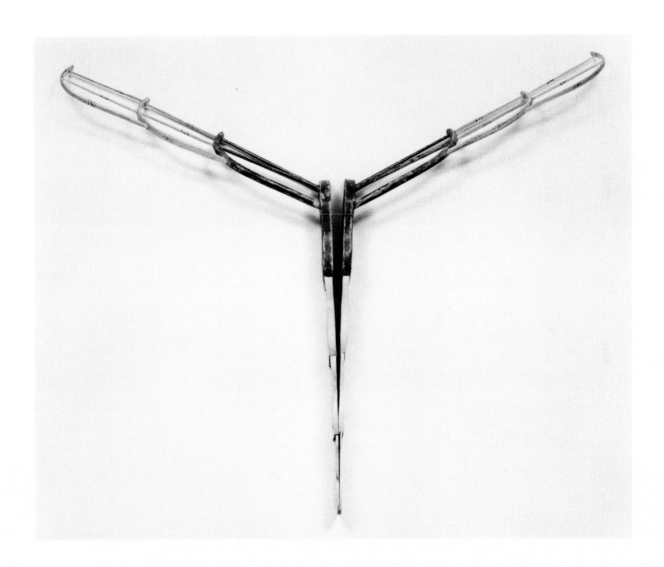

28. *Morning Bed* 1978
Painted wood chair, epoxy glue, glass, wire, and
wood dowels on concrete base
Wall piece: 35.6 x 96.5 x 20.3 cm (14 x 38 x 8 in.)
Floor piece: 94 x 45.7 x 101.6 cm (37 x 18 x 40 in.)
(dimensions variable)
Collection of the Museum of Contemporary Art,
Chicago, Illinois Arts Council Grant

29. *Portrait for Frida Kahlo* 1978
Painted wood chair, epoxy glue, and wood
dowels on concrete base
160 x 34.3 x 58.4 cm (63 x 13½ x 23 in.)
Collection of Mr. and Mrs. E. A. Bergman,
Chicago

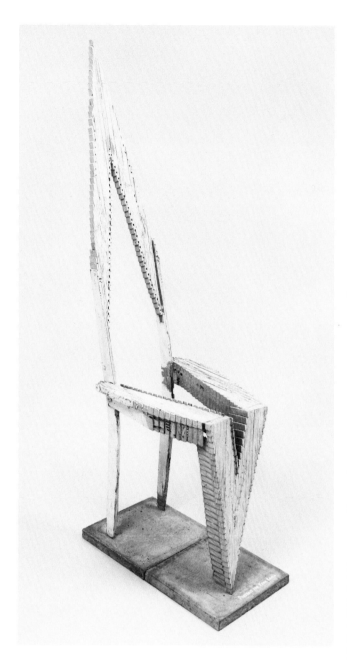

29

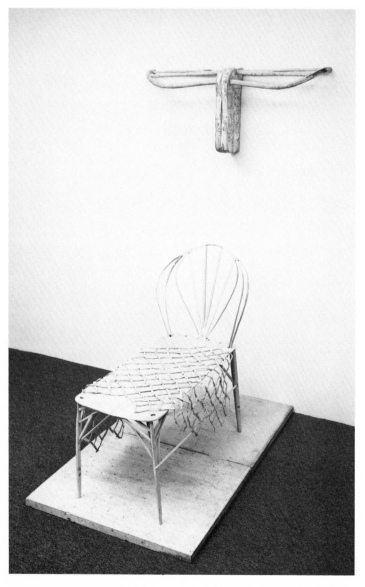

28

30. *Rain Cloud* 1978
Child's stained wood desk, epoxy glue, nylon
monofilament, staples, and wood dowels on
concrete base
177.8 x 109.2 x 50.8 cm (70 x 43 x 20 in.)
(dimensions variable)
Collection of Robert H. Bergman, Chicago

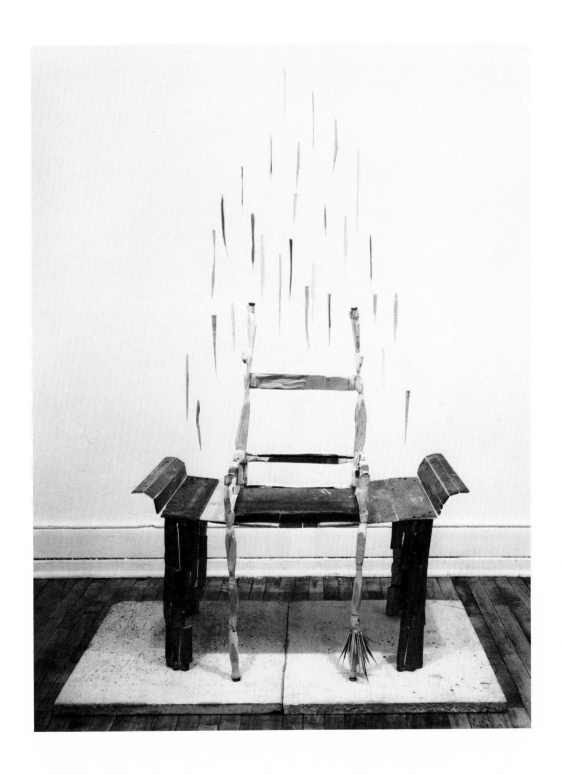

31. *Rainbow Skull* 1978
Partial painted wood chair, epoxy glue, pencil,
and wood dowels
99.1 x 73.7 x 38.1 cm (39 x 29 x 15 in.)
Collection of William H. Bengtson, Chicago

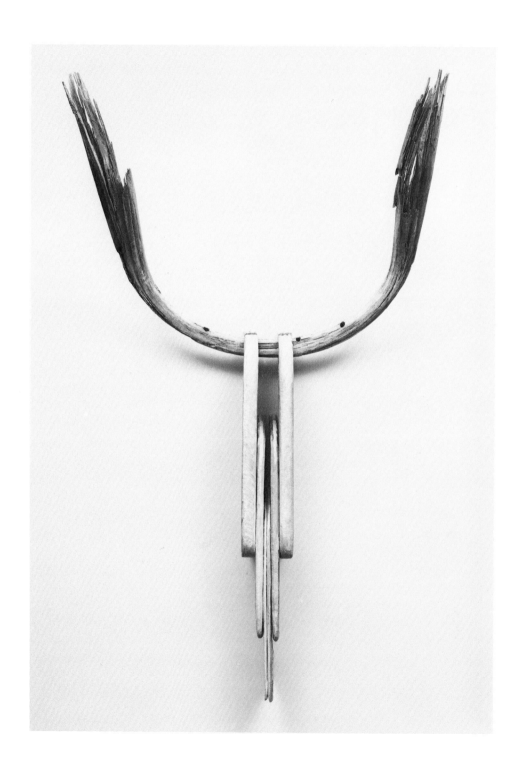

* 32. *Reversible Pegasus for Joseph Campbell* 1978
Partial child's stained wood chair, crucifix, epoxy
glue, glass, one issue each of *Natural History* and
Scientific American, reeds, stain, and wood
dowels on concrete base
142.2 x 88.9 x 41.9 cm (56 x 35 x 16½ in.)
Collection of Betsy and Andrew Rosenfield,
Chicago

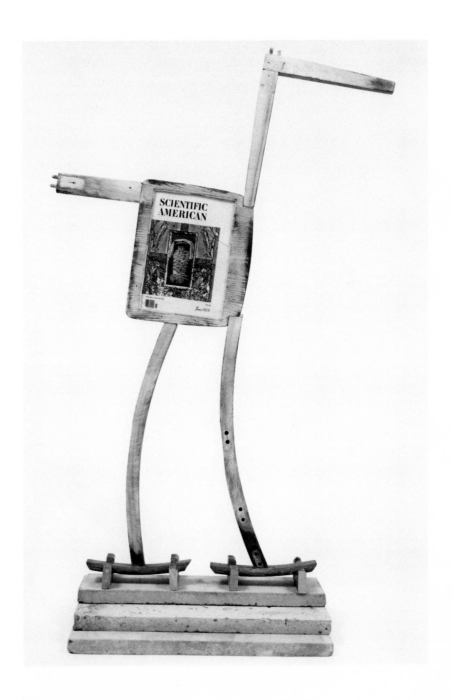

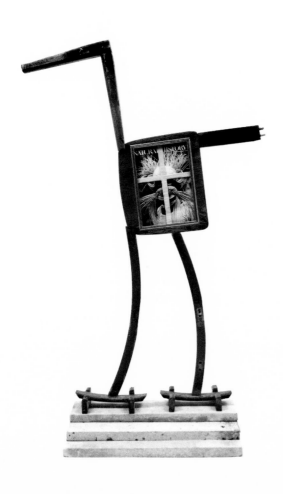

33. *Bantam Chair* 1979
Partial stained wood chair, epoxy glue, rocks,
stain, and wood dowels on terracotta tiles and
wood base
142.2 x 27.9 x 111.8 cm (56 x 11 x 44 in.)
Collection of William H. Plummer, Chicago

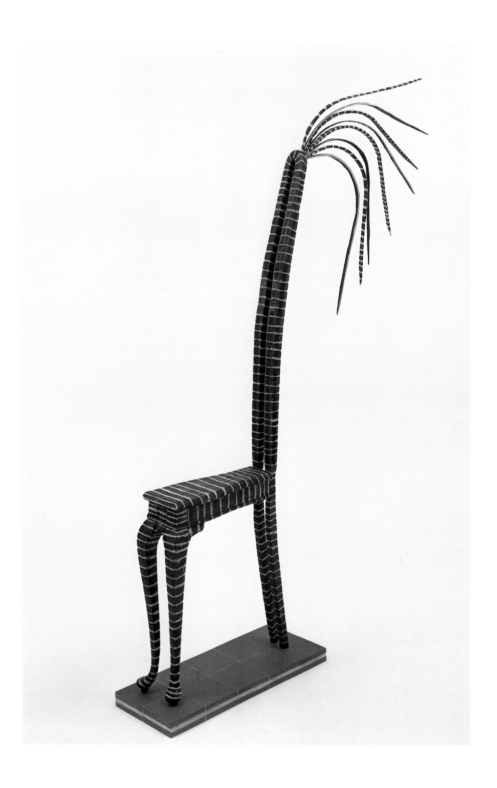

34. *Eiffel Tower* 1979
Partial stained wood highchair, epoxy glue, and wood dowels on concrete base
248.9 x 43.2 x 43.2 cm (98 x 17 x 17 in.)
Collection of Mr. and Mrs. Charles M. Diker, New York

* 35. *Figurine* 1979
Partial painted wood chair, pearlized epoxy glue, and wood dowels on painted concrete base
207.6 x 50.2 x 17.8 cm (81¾ x 19¾ x 7 in.)
Collection of Camille and Paul Oliver-Hoffmann, Chicago

36. *Paperweight* 1979
Partial painted wood chair, pearlized epoxy glue, and wood dowels on painted concrete base
156.2 x 68.9 x 14 cm (61½ x 27⅛ x 5½ in.)
Collection of Mr. and Mrs. Jerry I. Speyer, New York

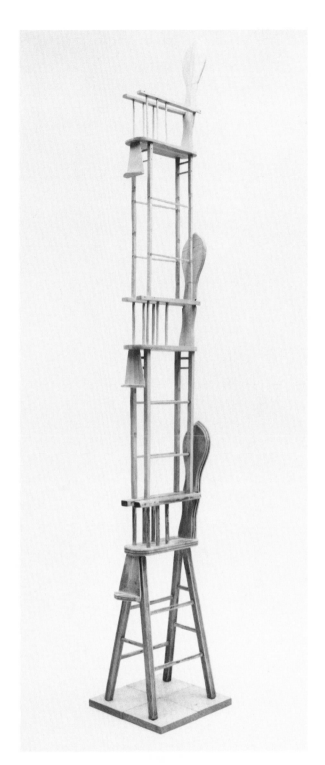

34

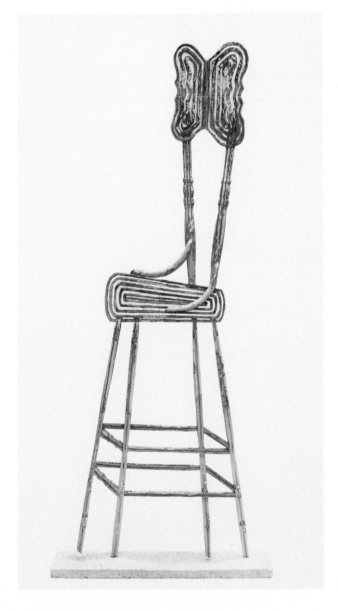

36

39

37. *Tall Story* 1979
Painted wood chair, epoxy glue, glass, and wood dowels on concrete base
203.2 x 92.1 x 137.2 cm (80 x 36¼ x 54 in.)
Collection of Sherry and Alan Koppel, Chicago

38. *Wallflower* 1979
Painted wood chair, epoxy glue, rhinestones, and wood dowels on concrete base
147.3 x 76.2 x 68.6 cm (58 x 30 x 27 in.)
Collection of Robert H. Bergman, Chicago
Cover illustration

39. *Acrobat* 1980
Baseball bat and wire
6.4 x 70.5 x 6.4 cm (2½ x 27¾ x 2½ in.)
Collection of Barbara and Russell Bowman. Milwaukee

40. *Acrobat* 1980
Baseball bat, epoxy glue, and wire
H. 86.4 cm; max. dia. 17.8 cm (34 in.; 7 in.)
Collection of Carol Celentano, New York

41. *Acrobat* 1980
Baseball bat, epoxy glue, pencil, and wood dowels
66.7 x 10.8 x 6.4 cm (26¼ x 4¼ x 2½ in.)
Collection of Karen Leininger, Chicago

42. *Acrobat* 1980
Baseball bat, wood dowels, and epoxy glue
50.8 x 29.2 x 7.6 cm (20 x 11½ x 3 in.)
Lent by the artist, courtesy of Phyllis Kind Gallery, Chicago and New York

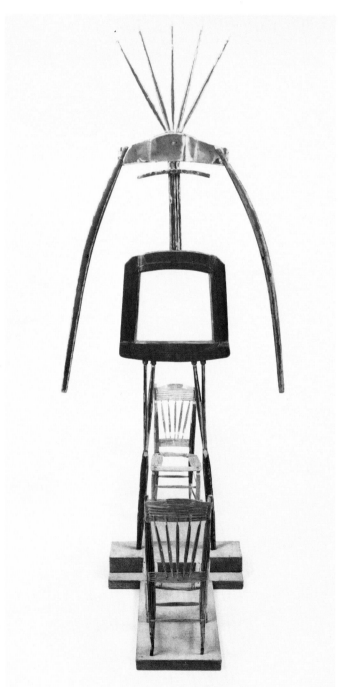

42

41

37

40

43. *Diamond Lill* 1980
Photograph, wood, epoxy glue, feathers, rhine-
stones, and wood dowels on concrete base
57.2 x 28 x 16.5 cm (22½ x 11 x 6½ in.)
Collection of Sherry and Alan Koppel, Chicago

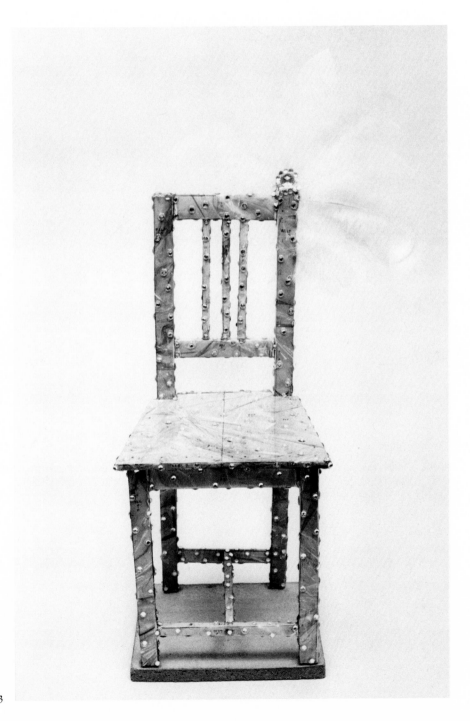

43

44. *General Nonsense* 1980
Painted wood chair, epoxy glue, seven partial
books, glitter, steel rods, and wood dowels
238.8 x 67.3 x 6.4 cm (94 x 26½ x 2½ in.)
(dimensions variable)
Collection of Doris and Robert Hillman,
New York

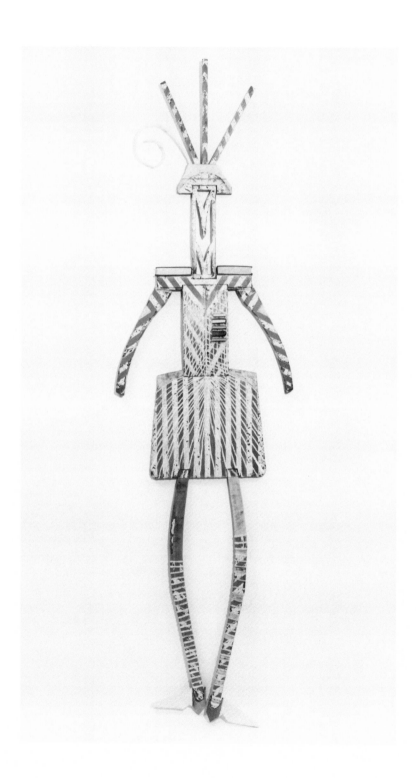

45. *Odalisque* 1980
Partial painted wood chair, epoxy glue, glitter,
wallpaper, and wood dowels
130.8 x 252.7 x 3.8 cm (51½ x 99 x 1½ in.)
Collection of Sherry and Alan Koppel, Chicago

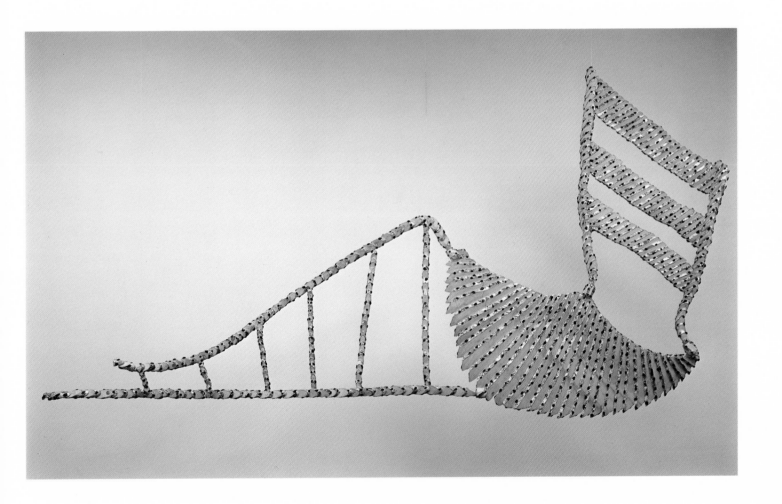

46. *Parrot Ship* 1980
 Painted wood chair, epoxy glue, paint, wood,
 and wood dowels on concrete base
 148 x 130.2 x 12.7 cm (58¼ x 51¼ x 5 in.)
 Collection of Susan and Lewis Manilow, Chicago

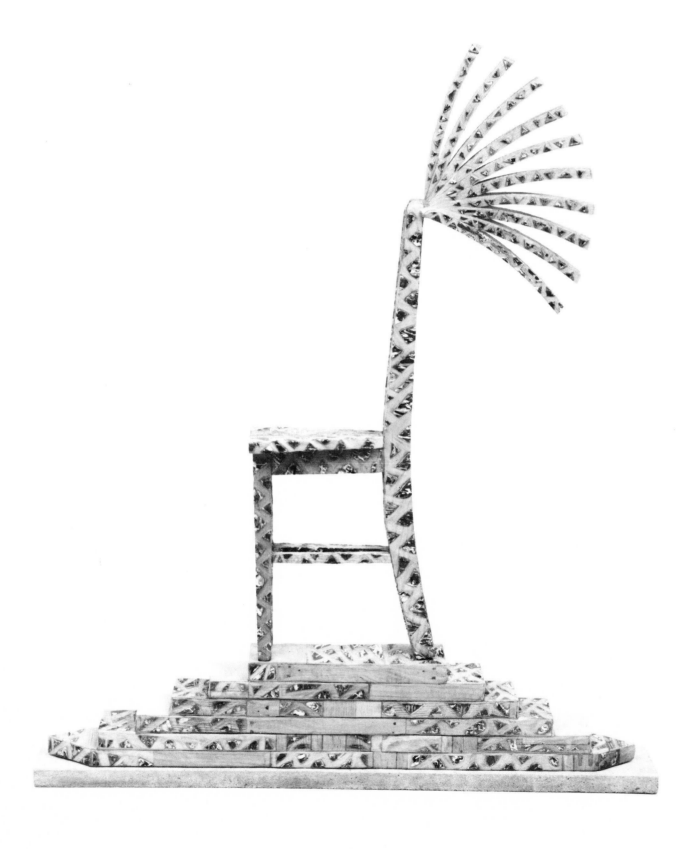

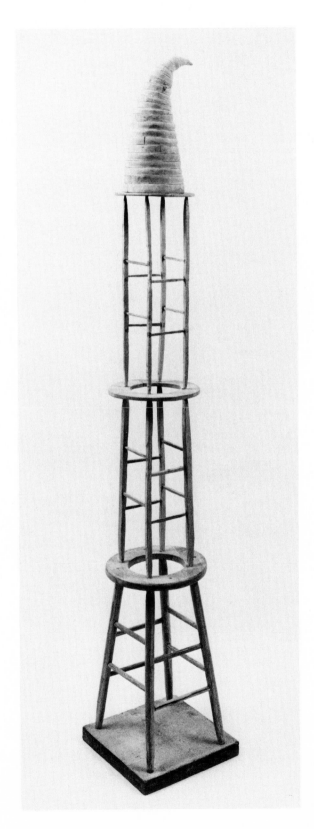

47

47. *Parsee's Hat* 1980
Painted wood stool, epoxy glue, and wood
dowels on concrete base
215.9 x 38.1 x 38.1 cm (85 x 15 x 15 in.)
Collection of Camille and Paul Oliver-Hoffman,
Chicago

48. *Sacred Bull* 1980
Photograph, wood, epoxy glue, paint, and
wood dowels on concrete base
48.3 x 24.8 x 15.9 cm (19 x 9¾ x 6¼ in.)
Collection of Sherry and Alan Koppel, Chicago

* 49. *Bookcolumn* 1981
Partial stained wood chair, books, epoxy glue,
wood, and wood dowels
322.6 x 40.6 x 1.9 cm (127 x 16 x ¾ in.)
Courtesy of Phyllis Kind Gallery, Chicago
and New York

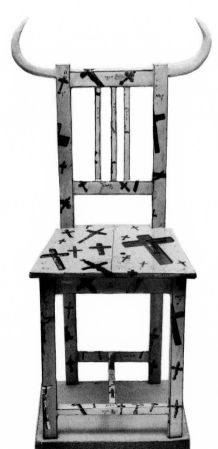

48

50. *Family* 1981
Painted wood chair, concrete, epoxy glue, plexi-
glass, photograph, wire, wood, and wood dowels
on concrete base
210.8 x 86.4 x 76.2 cm (83 x 34 x 30 in.)
Collection of Donald Marron, New York

* 51. *Jestress* 1981
Photograph, wood, bells, epoxy glue, glass beads,
and waxed twine on concrete base
101.6 x 33 x 17.1 cm (40 x 13 x 6¾ in.)
Collection of Sherry and Alan Koppel, Chicago

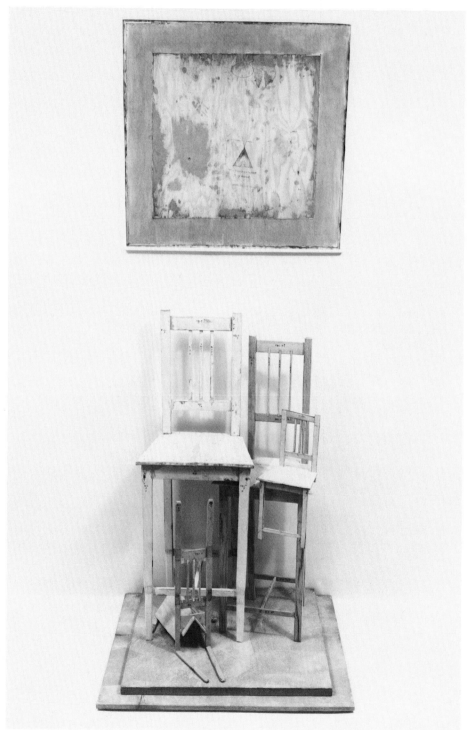

50

52. *Mockingbird* 1981
Small partial stained wood chair, epoxy glue,
paint, and wood dowels
152.4 x 152.4 x 33 cm (60 x 60 x 13 in.)
Lent by the artist, courtesy of Phyllis Kind
Gallery, Chicago and New York

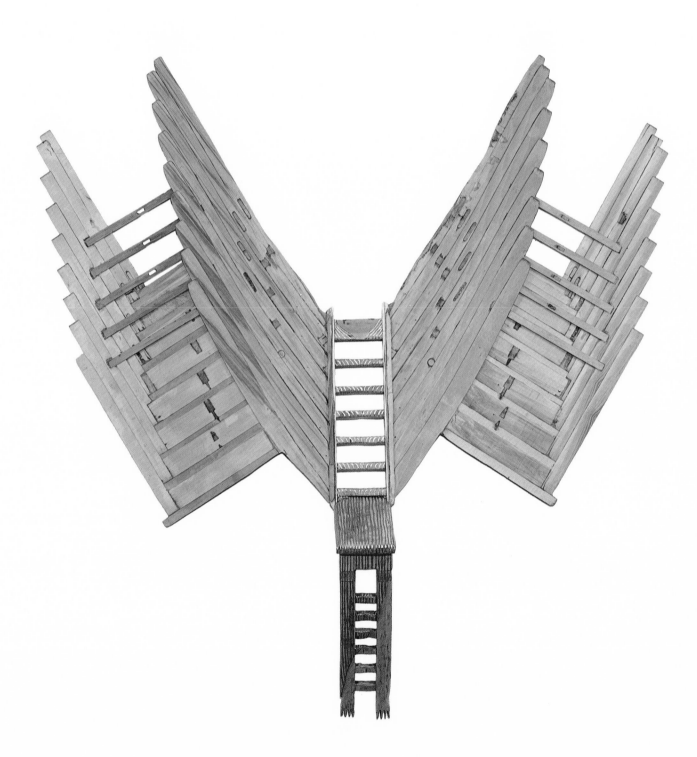

* 53. *Recital* 1981
 Photograph, wood, brass, epoxy glue, and wood
 dowels on concrete base
 134.6 x 58.4 x 71.1 cm (53 x 23 x 28 in.)
 Collection of William H. Plummer, Chicago

54. *Saturn* 1981
 Photograph, wood, epoxy glue, marbles, paint,
 and wood dowels on concrete base
 71.1 x 19.1 x 15.2 cm (28 x 7½ x 6 in.)
 Lent by the artist, courtesy of Phyllis Kind
 Gallery, Chicago and New York

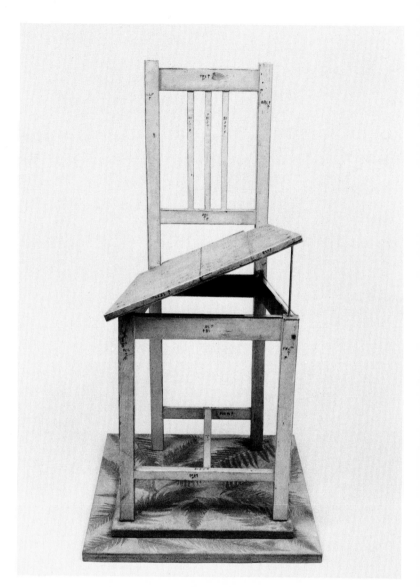

53

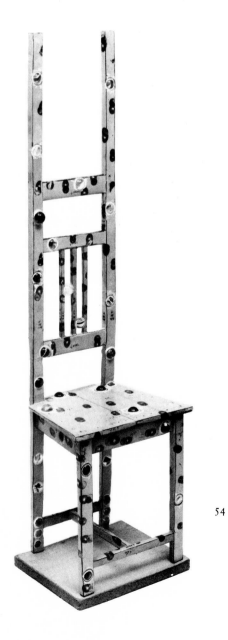

54

Photographs

The following works are lent by the artist, courtesy of Phyllis Kind Gallery, Chicago and New York.

55. *Inflated Lexicon* 1976
20.3 x 25.4 cm (8 x 10 in.)

56. *Lexicographer's Quilt* 1976
20.3 x 25.4 cm (8 x 10 in.)

57. *Maids-in-Waiting* 1976
27.9 x 35.6 cm (11 x 14 in.)

58. *Plastic Falls* 1976
27.9 x 35.6 cm (11 x 14 in.)

59. *Plastic Madonna* 1976
27.9 x 35.6 cm (11 x 14 in.)

60. *Plastic Pontiff* 1976
35.6 x 27.9 cm (14 x 11 in.)

61. *Anthesis* 1977
Seven photographs, each 16.5 x 11.4 cm
(6½ x 4¼ in.)
See fig. 9

62. *Making Friends* 1978
Six photographs, each 12.7 x 17.8 cm, 17.8 x
12.7, or 25.4 x 20.3 cm (5 x 7, 7 x 5, or 10 x 8 in.)
See fig. 11

63. *Valentine* 1978
27.9 x 35.6 cm (11 x 14 in.)

64. *World (Australia)* 1978
27.9 x 35.6 cm (11 x 14 in.)

65. *The Couple* 1979
35.6 x 27.9 cm (14 x 11 in.)

66. *Cradle* 1979
17.8 x 12.7 cm (7 x 5 in.)

67. *Drawbridge* 1979
20.3 x 73.7 cm (8 x 29 in.)
See fig. 10

68. *Lookout* 1979
20.3 x 49.2 cm (8 x 19⅜ in.)

69. *Loveseat* 1979
20.3 x 25.4 cm (8 x 10 in.)

70. *Wallflower* 1979
35.6 x 27.9 cm (14 x 11 in.)

71. *Global Seat* 1979
Two photographs, each 20.3 x 25.4 cm (8 x 10 in.)

72. *Morning Rose* 1979
35.6 x 27.9 cm (14 x 11 in.)

73. *Portfolio* 1979
Nine photographs, each 20.3 x 25.4 cm (8 x 10 in.)

74. *Silver Screen* 1979
27.9 x 35.6 cm (11 x 14 in.)

75. *Skyway* 1979
35.6 x 27.9 cm (14 x 11 in.)

76. *Darth Vader* 1979
35.6 x 27.9 cm (14 x 11 in.)

77. *Theatre* 1979
27.9 x 35.6 cm (11 x 14 in.)

78. *Cross-Reference* 1980
114.9 x 82.6 cm (45¼ x 32½ in.)

79. *Marble Seat* 1980
114.9 x 82.6 cm (45¼ x 32½ in.)

80. *Pattern* 1980
114.9 x 82.6 cm (45¼ x 32½ in.)

Selected Exhibitions

1973 Artemisia Gallery, Chicago, group show

1974 Art Institute of Chicago, "Seventy-fifth Exhibition by Artists of Chicago and Vicinity" (exh. cat.)

Artemisia Gallery, Chicago, "Barbara Grad/Margaret Harper"

Illinois Center One and Two, Chicago, "40 Artists of A.R.C. and Artemisia Gallery at One and Two Illinois Center"

1975 Artemisia Gallery, Chicago, "Sandra Gierke/Margaret Harper/ Carol Turchan"

North River Gallery, Northeastern Illinois University, Chicago, "Freya Hansell, Margaret Harper, Kate Horsfield, Elva Maltz, Jan Sullivan: Sculpture"

Art Institute of Chicago, fellowship show

Union League Club of Chicago, "3-D '75"

1976 Indianapolis Museum of Art, "Painting & Sculpture Today 1976" (exh. cat.)

Krannert Art Museum, Champaign, Illinois, "Paintings and Sculpture by Midwest Faculty-Artists" (Traveled to Indiana University Art Museum, Bloomington) (exh. cat.)

Phyllis Kind Gallery, Chicago, "Margaret Agnes Wharton— Chairs"

School of the Art Institute of Chicago Gallery, "Painting and Sculpture: Distinguished Alumni 1945 to the Present"

1977 Art Institute of Chicago, "Seventy-sixth Exhibition by Artists of Chicago and Vicinity" (exh. cat.)

Artemisia Gallery, Chicago, "Strong Works"

Institute of Contemporary Art, University of Pennsylvania, Philadelphia, "Improbable Furniture" (Traveled to La Jolla Museum of Contemporary Art, California and Museum of Contemporary Art, Chicago) (exh. cat.)

Phyllis Kind Gallery, New York, "Margaret Wharton"

1978 John Michael Kohler Arts Center, Sheboygan, Wisconsin, "American Chairs: Form, Function, and Fantasy" (exh. cat.)

N.A.M.E. Gallery, Chicago, "Daley's Tomb"

Nancy Lurie Gallery, Chicago, "Chicago: Self-Portraits" (exh. cat.)

Phyllis Kind Gallery, New York, "Margaret Wharton"

1979 Aspen Center for the Visual Arts, Colorado, "American Portraits of the Sixties and Seventies (exh. cat.)

Art Institute of Chicago, "Chicago and Vicinity: Prizewinners Revisited" (exh. cat.)

Art Institute of Chicago, "100 Artists 100 Years" (exh. cat.)

Chicago Public Library Cultural Center, "The Result of a Bizarre Activity . . . S.A.I.C. Alumni Sculpture Show"

Museum of Contemporary Art, Chicago, "New Dimensions: Volume and Space" (exh. cat.)

N.A.M.E. Gallery, Chicago, "7 x 9"

Phyllis Kind Gallery, New York, "Margaret Wharton"

School of the Visual Arts, New York, "The Intimate Gesture"

1980 Contemporary Arts Center, Cincinnati, "Chicago, Chicago" (exh. cat.)

Indianapolis Museum of Art, "Painting & Sculpture Today 1980" (exh. cat.)

Mayor Gallery, London, "Six Artists from Chicago"

Phyllis Kind Gallery, Chicago, "Margaret Wharton"

Reicher Gallery, Barat College, Lake Forest, Illinois, group show

1981 Chicago Public Library Cultural Center, "City Sculpture"

Phyllis Kind Gallery, New York, "Margaret Wharton"

Selected References

Franz Schulze, "The Chicago Show—there's nothing like it," *Chicago Daily News,* December 14-15, 1974.

Dorothy Andries, "Shore artist wins Logan prize," *Glenview Announcements,* January 2, 1975.

Jane Allen and Derek Guthrie, "Artemisia Triumphs in C. and V. Show," *The New Art Examiner* 2, 4 (January 1975): 1.

Chris Kohlmann, "Chicago and Vicinity—As You Like It," *Midwest Art* 1, 11 (January 1975): 1-8.

Nory Miller, "Cheers, chairs," *Chicago Daily News,* February 21-22, 1976.

Robert Glauber, "An artist 'to buy early' is M. A. Wharton," *Skyline,* Chicago, February 25, 1976.

Devonna Pieszak, "Margaret Agnes Wharton," *The New Art Examiner* 3, 6 (March 1976): 15.

Susan Lecky, "Painting and Sculpture by Midwest Faculty-Artists," *The New Art Examiner* 3, 8 (May 1976): 20.

Peter Schjedahl, "Letter from Chicago," *Art in America* 64, 4 (July-August 1976): 52-58.

Sharon Edelman, ed., *Artpark, The Program in Visual Arts 1974-1976,* Buffalo: University Press, State University of New York at Buffalo, 1976.

John Perreault, "Margaret Wharton," *Soho Weekly News,* April 21, 1977.

Ellen Lubell, "Margaret Wharton," *Arts Magazine* 51, 10 (June 1977): 45.

"Margaret Wharton," *Art News* 76, 8 (October 1977): 139.

C. L. Morrison, "Chicago: 'Strong Works,' Artemisia Gallery," *Artforum* 16, 4 (December 1977): 74.

Suzanne Delehanty, "Furniture of Another Order," in *Improbable Furniture,* exh. cat., Institute of Contemporary Art, University of Pennsylvania, Philadelphia, 1977.

Linda Kramer, "Artist to Artist: Margaret Wharton," *The New Art Examiner* 5, 4 (January 1978): 7, 10.

Joshua Kind, "Art and the Corps of Women," *The New Art Examiner* 5, 6 (March 1978): 10-11.

Jeffrey Hoffeld, "Chairperson Margaret Wharton," *Arts Magazine* 53, 3 (November 1978): 160.

Grace Glueck, "Photography: 1940's New York/Margaret Wharton," *New York Times,* December 29, 1978.

Devonna Pieszak, "The Chair Speaks: Margaret Wharton's Objects of Uncommon Personality," *The New Art Examiner* 6, 4 (January 1979): 4-6.

Jane Allen and Derek Guthrie, ". . . and sculpture up against a wall," *The New Art Examiner* 6, 8 (May 1979): 5.

Barbara Aubin, "New Dimensions: Volume and Space," *Visual Dialog* 4, 3 (Spring 1979): 16-17.

Carrie Rickey, "Chicago," *Art in America* 67, 4 (July-August 1979): 47-54.

Alan G. Artner, "Quality comes out of Wharton wood work," *Chicago Tribune,* January 11, 1980.

Joanna Frueh, "Chair Persons: Margaret Wharton," *The Reader,* Chicago, January 11, 1980.

Michael Bonesteel, "Reviews in Brief: Margaret Wharton," *The New Art Examiner* 7, 6 (March 1980): 16.

Roberta Smith, "Angels with Dirty Faces/Margaret Wharton," *The Village Voice* 26, 15 (April 8-14, 1981): 90.

Judd Tully, "The Chicago art scene," *Flash Art* 103 (Summer 1981): 23-26.

Robert Glauber, "Margaret Wharton," *Arts Magazine* 56, 1 (September 1981): 84.

Lenders to the Exhibition

Evelyn and Lawrence Aronson, Glencoe, Illinois
Mr. and Mrs. Roger W. Barrett, Winnetka, Illinois
Jerrold Basofin, Chicago
William H. Bengtson, Chicago
Mr. and Mrs. E. A. Bergman, Chicago
Robert H. Bergman, Chicago
Barbara and Russell Bowman, Milwaukee
Roger Brown, Chicago
Carol Celentano, New York
William Copley, New York
Mr. and Mrs. Charles M. Diker, New York
Gerald A. Gitles, Chicago
Milly and Arnold Glimcher, New York
Doris and Robert Hillman, New York
Phyllis Kind Gallery, Chicago and New York
Dr. and Mrs. Robert H. Kirschner, Chicago
Sherry and Alan Koppel, Chicago
Karen Leininger, Chicago
Linda and Harry Macklowe, New York
Susan and Lewis Manilow, Chicago
Donald Marron, New York
Susan and Chuck Michod, Chicago
Camille and Paul Oliver-Hoffmann, Chicago
Mr. and Mrs. John B. Pittman, St. Charles, Illinois
William H. Plummer, Chicago
Betsy and Andrew Rosenfield, Chicago
Maxine and Jerry Silberman, Glencoe, Illinois
Mr. and Mrs. Jerry I. Speyer, New York
Margaret Wharton, Glenview, Illinois
Joan and Michael W. Zavis, Highland Park, Illinois